# SECRET
# CHESTER

John Idris Jones

AMBERLEY

*This book is dedicated to the memory of the following architects, without whose significant work Chester would not be what it is today:*

Thomas Harrison (1744–1829)
James Harrison (1814–1866)
Thomas M. Penson (1818–1864)
John Douglas (1830–1911)
Thomas M. Lockwood (1830–1900)

*With warm thanks to James A. Jones for his work with the images.*

First published 2017

Amberley Publishing
The Hill, Stroud, Gloucestershire, GL5 4EP
www.amberley-books.com

Copyright © John Idris Jones, 2017

The right of John Idris Jones to be identified as the Author of this work has been asserted in accordance with the Copyrights, Designs and Patents Act 1988.

ISBN  978 1 4456 6894 9 (print)
ISBN  978 1 4456 6895 6 (ebook)

British Library Cataloguing in Publication Data.
A catalogue record for this book is available from the British Library.

Origination by Amberley Publishing.
Printed in Great Britain.

# Contents

# Introduction

This book is designed to be an introduction, or reintroduction, to the remarkable city of Chester.

For the best part of four months I have researched, travelled and photographed its length and breadth, searching out the story behind the story – its most interesting details and features fitting in with the 'Secret' title.

This is not a gazetteer of buildings, nor a history book; it is a varied series of images and short descriptions of details, features, objects, façades, and buildings selected from the current situation, street scenes and landscapes. These originate from centuries of history, but some are recent. They are chosen for presentation here because they humanise the past, and show how things were at the time, as well as how they are in the present.

Chester is unique, and is certainly one of the most culture-rich places in the United Kingdom. Its story starts long before the Romans, who came here with a view to establish it as a base from which to conquer the north of England, and from which to penetrate north Wales. The Celts had then been here for at least two centuries (records are scarce), and then the Saxons and Normans colonised it. As a result of this the British emerged. In the buildings still here today we can see the style and purpose of the Tudor period. Some of the oldest inhabited buildings are from the first half of the sixteenth century, such as the half-timbered buildings in Lower Bridge Street. The Tudor half-timbered, black-and-white building style is the template for the 'Chester style'. This was expanded, developed, and made much richer in the nineteenth century by a number of talented local architects – Chester was lucky to have them. It is the only city in Great Britain to contain 'The Rows' – a late medieval feature of its townscape – and these architects tried to preserve them.

It is hoped that this book is easy to use and in its considerable scope and variety gives individuals, families with children, and tourists a good reason to get out and explore. It is a book to enjoy because Chester is enjoyable. Point out details to your children, let their eyes study the amazing features of design, artwork and architecture that exist in every street. The city has grown, developed and become more complex, yet coherent, over the last 2,000 years, extending its personality. It has evolved into something extraordinary. I hope you will enjoy this attempt to introduce you to some aspects of its unique character.

JIJ, 2017

# 1. Chester High Cross

The Cross is the heart of Chester. It sends its energies out along Eastgate Street, Northgate Street, Watergate Street and Bridge Street. These four streets were the main roads in Chester when it was under Roman control. To the north of the point where Bridge Street meets the two other roads was the headquarters of the Roman occupation. St Peter's Church stands on the site of this centre of Roman life.

The monument known as the High Cross is fourteenth century in origin. It has a hexagonal crown, a plinth and shaft – the moulded shaft base is medieval. The head is badly weathered. The cross was badly damaged during the surrender of Chester to the Parliamentarians in 1646.

This central junction is a meeting point. In the summer months, the town crier turns up here in all his magnificent regalia (crimson coat, black cap, etc.). His voice carries down the four streets, announcing the events of the day.

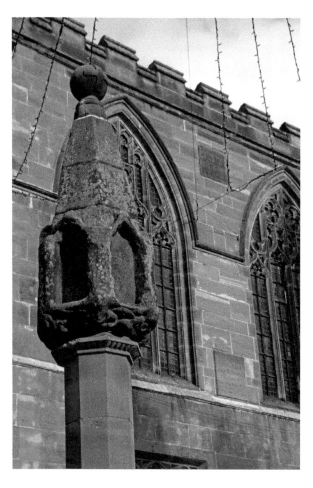

Fourteenth-century monument, the High Cross.

# 2. The Hermit of Godstall Lane

**DID YOU KNOW ?**

Godstall Lane had a hermit. Gerald of Wales wrote that this man was Henry V of the Holy Roman Empire.

This lane joins St Werburgh Street and Eastgate Street. In the early years, it was a path towards the Abbey of St Werburgh, later Chester Cathedral. The lane, during the Roman occupation, marked the eastern boundary of the legionary commander's residence – the *praetorium*.

The name Godstall means 'God's place'. There is a tradition that a hermit lived here in the twelfth century.

Godstall Lane, joining St Werburgh Street and Eastgate Street.

# 3. Site of the Gee-Gees

Races were held on Shrove Tuesday and St George's Day, both major festivals during the medieval period. In 1745, a four-day event was introduced.

The course itself is short – just over 1 mile long. It is traversed anti-clockwise and it has a very short finishing straight (239 yards). Larger horses with long strides are at an advantage.

The primary event is in May, and includes the Chester Cut and the Chester Vase. Other races are the Earl Grosvenor Stakes and the Henry Gee Stakes.

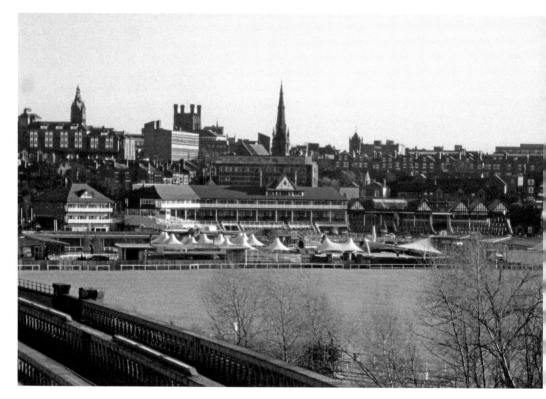

Chester racecourse.

# 4. Falling Water in the Cloisters

The sound of falling water soothes us. This sound features in the cloisters of the cathedral. The sight of flowers calms us too, and around the walls there are many. In a squared-off pool in the centre there is a circle that balances the square. Harmony prevails. Water falls continuously, in a fine line. The lady looks down; the man looks up. Both hold the open bowl. When it rains, the rain falls into the bowl and runs over the rim. Overflowing, it falls in no predictable way, but it is always there. We live within its sound. Mutually, both figures focus on their purpose; they intermingle, their slim arms framing and causing.

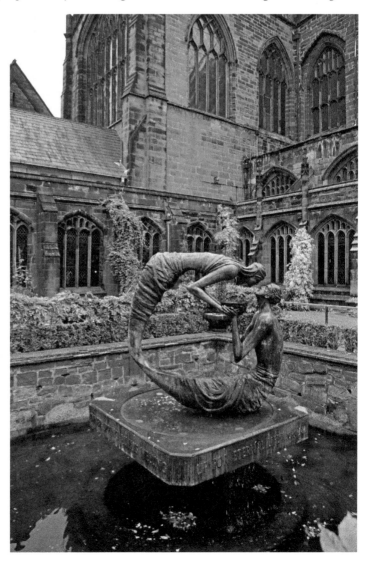

Chester Cathedral
cloisters sculpture.

There is a conjoining here. There is the product of being together.

The two figures are the colour of pale seaweed, their shapes formed by familiarity with rain, wind and sea. Here the elements combine, circular and smooth. We are their product. Jesus said, 'that water that/ I shall give will be/ an inner spring always welling/ up for eternal life' (John 4: 14).

The sculpture *The Water of Life* was created by Stephen Broadbent, and was set in the cloisters in 1994.

# 5. The Old Music Hall

## DID YOU KNOW ?

Charles Dickens performed here in the 1860s.

Charles Dickens was here.

On St Werburgh Street, 100 yards or so from the south face of the cathedral, is a sandstone building now used as retail premises. A building on this site was originally St Nicholas's Chapel, built for Simon de Albo, the abbot of St Werburgh's. For a time, it was the church of the parish of St Oswald, being converted to the Mayor and Assembly of Chester in 1488. From around 1750, it was used as a playhouse, as the New Theatre in 1773 and Theatre Royal in 1777.

The architect James Harrison (1814–66) is regarded as the pioneer of introducing the black-and-white style to Chester. In 1854 he designed a new music hall here in Gothic style. The lane leading to Northgate Street next to this building is Music Hall Passageway. The adjacent sandstone wall is original.

# 6. The Grosvenor Bridge

## DID YOU KNOW ?

The Grosvenor Bridge has the largest stone-built span of all bridges in the UK. During the Second World War a local pilot flew his aeroplane through the bridge's arch.

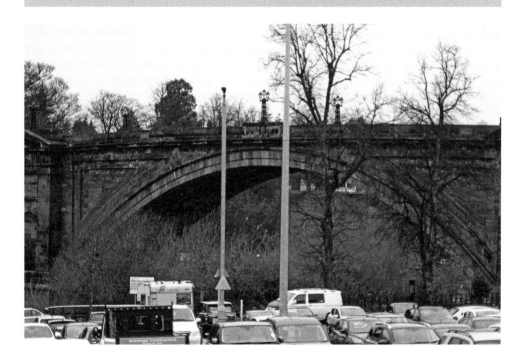

Grosvenor Bridge.

This elegant bridge is the longest single-span stone bridge in Britain. It carries the A483 road over the River Dee, bringing heavy traffic into the city from the south. In 1995, it was closely examined and was deemed safe enough to carry traffic ten times the load it was originally designed for.

It was designed by Chester architect Thomas Harrison (1744–1829), who studied in Rome and initially designed buildings in Lancaster and country houses in Scotland. In 1795 he moved to Chester. In 1786 he designed a new law court and prison in Chester, and then he was commissioned to design a new bridge for the increasing traffic. Almost all his work is in the north-west of England. He was appointed County Surveyor for Cheshire.

He added to the nearby Old Dee Bridge to strengthen it. A new approach road, Grosvenor Street, was created to join with the new bridge, which was costed by Thomas Telford. The foundation stone was laid in 1827 by the Earl of Grosvenor. The bridge was formally opened in 1832 by the future Queen Victoria. The total cost of the bridge was near to £50,000, but Harrison did not see it completed because he died in 1829. During the design period, he created a stone model of his new bridge. It can be seen on the embankment below the castle, on the left of the road down to the lower car park.

The Grosvenor Bridge is almost 60 feet high, with a span of nearly 200 feet. This structure is listed by English Heritage as Grade I, category A – fewer than 3 per cent of listed buildings are in this category. Category A consists of 'buildings of national or international importance, either architectural or historic'.

A point of interest is that during the Second World War a local vet, Jimmy Storrar, flew his Hawker Hurricane under the arch of the bridge.

# 7. The Abbey Gateway

Walk through this archway from Northgate Street to Abbey Square to experience one of the oldest sights in Chester. This sandstone archway is dated around 1300; the upper storey was rebuilt around 1800. This gateway was formerly the main access to the precinct of St Werburgh's Abbey, now Abbey Square – the abbey became the cathedral. Near the top, in the centre, is a sixteen-pane window within a Gothic arch. It is a Grade I-listed building.

The interior face of the archway has a three-bay vault. The front room above the arch was originally a robing room, fitted with cupboards. One cupboard panel, above the door, is inscribed 'EDMUND CHESTER'. The armorial panel immediately north of the doorway is inscribed 'SAMUEL PEPOE LL B, Chancellor'. The hollow chamfers can be compared with the vault of the undercroft of Nos 28 and 34 Eastgate Street (Browns of Chester).

(The *Abbey Square Sketch Book* was published in three volumes, the first in 1872. It contains sketches, drawings and photographs, some by John Douglas. He designed the title page and created a sketch of the Abbey Gateway.)

The secret here is the contrast between the sculpted veins of this late medieval gateway and the sharp classical outlines of the Georgian-style terrace houses edging the Square. There are over 400 years between their respective origins.

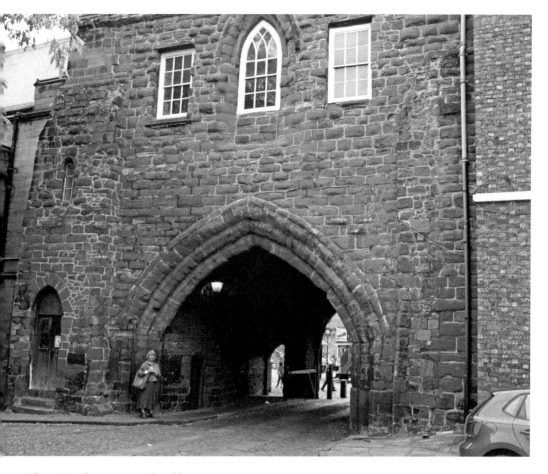

The original gateway to the abbey.

# 8. The Crypt, Eastgate Street

During the 1850s and 1860s, Thomas Mainwaring Penson (1818–64) was busy designing major buildings in Chester. These included the Queen's Hotel, the Grosvenor Hotel and the Crypt Chambers (1858) at No. 28 Eastgate Street. This is in the Gothic Revival style, which is the second style (after black-and-white) to characterise Chester's renaissance in building during the Victorian period. The exterior has four storeys, including an undercroft and row, in a High Gothic style.

There are five steps down to the undercroft lobby. The undercroft is partly medieval; openings have concave chamfers, probably dating from around 1300, and there are rib-vaulted bays. The ribs are chamfered. This secreted construction can be compared with the nineteenth-century remodelling.

This is a much-admired design, beautifully finished.

The Crypt, Eastgate Street.

# 9. *Messiah* in the Cathedral

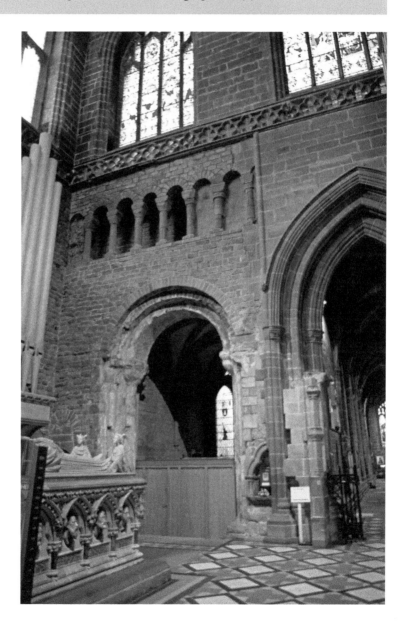

The cathedral where the *Messiah* was first performed.

George Frederick Handel composed his great oratorio in 1741/2. He intended it to be first performed in Dublin, Ireland, but he was delayed in crossing because of rough seas. The intention was to sail from Park Gate, on the Wirral. He stayed in the Golden Falcon Inn on Northgate Street, Chester, close to the gateway, under the hospitality of the Kenna family, for a few days. The inn does not exist now. Handel gathered together musicians from the cathedral and elsewhere and played a rehearsal of his oratorio in the cathedral.

# 10. Chester Town Hall

This towering building on Northgate Street was designed by William Henry Lynn (1829–1915) in Venetian Gothic style, and was completed in 1869. It succeeded the previous town hall, designed by Thomas Harrison on the castle site.

Lynn's building is of an earlier style – late thirteenth century. Above the two central bays the tower has three faces, which include clocks.

Thomas Lockwood (1830–1900) is another architect to leave his mark on Chester. His way with timber framing was exemplary, managing to complete unity out of many

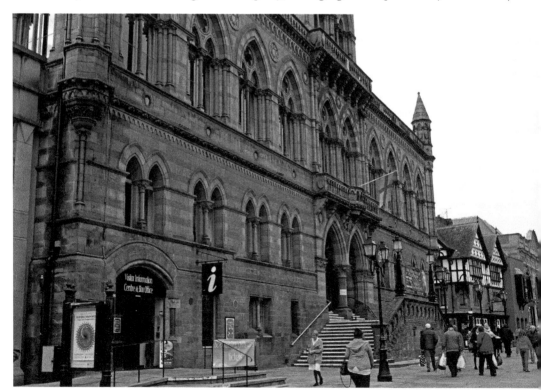

Chester's imposing Town Hall.

disparate elements. His building at No. 1 Bridge Street takes the building around the corner with Eastgate Street in a way that is elegant, unified and striking. He designed the Grosvenor Museum in 1885 and he executed the complex half-timbering of buildings in Foregate Street in 1895/6.

He designed the council chamber of the town hall in 1898. This impressive space is an enclave of the Jacobean Revival style in a High Gothic Hotel de Ville, with oak panelling, Corinthian pilasters in the west gallery, which has access from Princess Street via the stair turret, and the pre-1974 arms of the city of Chester. The ceiling has a deep plaster frieze with patterns of leaves, there are sandstone corbels in bird patterns, and there are four ornate chandeliers. The staircase is outstanding, rising in an apse. There are many displays of interesting insignia.

Chester Town Hall is a popular place for formal meetings. Weddings are held in its powerful, colourful, ornate interior.

# 11. Chester City Club

Designed by Thomas Harrison in 1807 in a style known as Greek Revival, it is built of yellow ashlar stone on the front and brown brick on the sides and rear. There are two

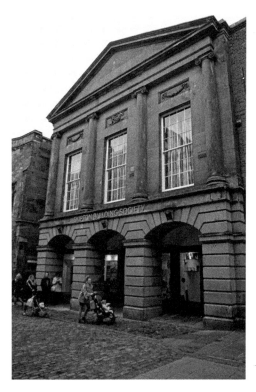

Northgate Street building by Thomas Harrrison, 1807.

storeys to the front and three to the back. The Northgate Street façade includes a three-bay arcade. In the upper storey, there are four Ionic pillars, creating three bays.

It was designed by Harrison as a gentleman's club, called the Commercial News Room, and measures around 40 feet by 25 feet. It opened in 1808. Pevsner writes, 'It is a beautiful ashlar-faced building.'

On each side of the building there are passages leading to St Peter's churchyard.

This is a very fine design, a contrast (though earlier) with the usual busy half-timbering of Chester's Victorian new facades.

# 12. The South Transept Window of Chester Cathedral

This magnificent construction, in High Victorian glass (created by Heaton Butler & Bayne in 1887), can be described as 'flowing, decorated Gothic'.

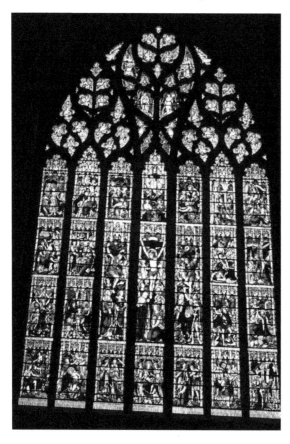

South transept window, Chester Cathedral, 1887.

It is dedicated to William Tatton Egerton and Wilbraham Tatton Egerton. William was a major landowner from the Manchester area. In 1859 he was raised to the peerage as Baron Egerton of Tatton in the County Palatine of Chester. Palatine is an area status dating from the late Middle Ages, when the application of law and authority was distributed to the regions. From 1832 to 1858 he was MP for Cheshire North; from 1868 until his death in 1883 he served as Lord-Lieutenant of Cheshire. Wilbraham, the 2nd Baron Egerton of Tatton, who restored this window, was his eldest son and heir.

# 13. The Welsh – Beware of Chester at Night

## DID YOU KNOW ?

A Welsh man could be murdered inside Chester's walls at night...

Killing a Welsh man within the walls.

The legend is still passed-on – we believe it is only a legend! However, a bylaw citing this is said to be still in existence (see the website 'Discover Chester').

The story is that those of Welsh origin can, with impunity, be killed at night in Chester. It can only happen between midnight and sunrise and within the walls of the city. The victim can only be 'legally' killed with an arrow, shot from a hand-held bow. One version of the legend says the bow must be made of ash.

This may be a metaphor dating back to the Dark Ages. At one time, Chester was included in the Welsh territory of Powys, and was the principal settlement. King Arthur is said to have fought a battle here.

In AD 616 a battle took place in Chester between the Northumbrian army and the Mercians. Some 1,200 Welsh monks were murdered in a battle that took place on the banks of the Dee, next to Handbridge. The monks were from Bangor-on-Dee and were attacked by the army of King Aethelfrith. The Welsh were separated from their kin in Cornwall and Cumbria, and it can be said that the history of a separate Wales can be dated from this time. Severe enmity towards the Welsh may have been engendered as a result, and the story perhaps took root as a warning for the Welsh to stay away.

# 14. Saint Werburgh and the Goose

Catholic legend tells the story of Werburgh, an Anglo-Saxon princess of the seventh century, who was born in Stone, now in Staffordshire. She is the patron saint of Chester and her feast day is the 3 February.

There is a story that she restored a dead goose to life. Another story tells how she banished all geese from the village of Weedon, Northamptonshire. Her remains were moved because of Viking raids on the Church of St Peter and St Paul, a site now occupied by Chester Cathedral. In the eleventh century, the Welsh king Gruffudd ap Llywelyn and his army attacked Chester. His defeat and withdrawal is attributed to Saint Werburgh's protection of Chester.

In 1540, the Dissolution of the Monasteries led to the creation of Chester Cathedral. A shrine to Saint Werburgh remains on display in the cathedral's Lady Chapel, behind the main nave. The statue of the saint has a goose beside it.

The goose stories start with a flock that was destroying the corn fields of Weedon. Saint Werburgh commanded them to depart, and they were never seen again. Another story has the geese visiting the convent meadow in Weedon. One goose was a favourite of Saint Werburgh and she called him Greyking – he was fat and happy and had a black ring around his neck. However, the convent steward fancied this goose for supper. Saint Werburgh was very annoyed with this steward, Hugh. She looked around and found the bones of the goose. She stood before them and ordered them to reform, so that the goose would come back to life. This, by a miracle, happened, and the recreated goose came alive before her and walked away, back to his flock.

St Werburgh's goose effigy in the cathedral.

# 15. Stanley Palace, No. 83 Watergate Street

This grand building was originally built in 1591 for Sir Peter Warburton. He died in 1621 and his house was inherited by his daughter. She married Sir Thomas Stanley, of the prestigious and very wealthy Earls of Derby (West Derby, Merseyside) dynasty. This house was their Chester home. James Stanley (the 7th Earl) lived here through the Civil Wars and was held here under house arrest. From here he was taken to Bolton and executed.

Stanley Palace was built when many wealthy families built themselves houses on a generous plot of land in Chester. Original features of the house are three gables and a highly decorated façade.

In 1866 there was a proposal to dismantle the structure and take it to the USA, but this was thwarted by the Chester Archaeological Society. The building is owned by Chester City Council.

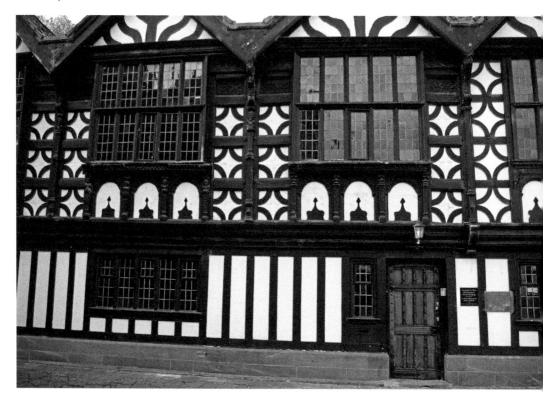

1591 house in Watergate Street.

The secret behind this building is its connection with the Warburton and Stanley families – the latter especially. This illustrates the high point Chester occupied in the early history of England.

# 16. Bishop Lloyd's House, No. 41 Watergate Street

The architectural historian Nicholas Pevsner considered this 'perhaps the best house' in the city. It is listed as Grade I in the National Heritage List for England.

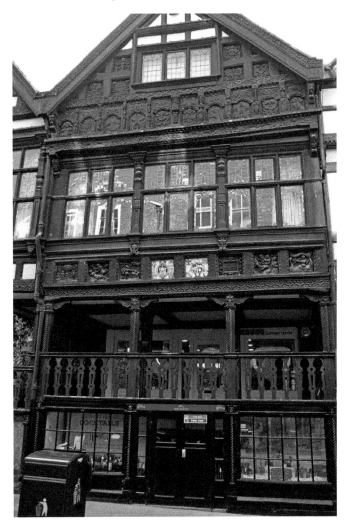

Bishop Lloyd's house in Watergate Street.

The undercrofts are on two storeys. Originally from the thirteenth and fourteenth centuries, it was altered during the seventeenth century when the two houses were combined into one. It contains a magnificent fireplace and heavily decorated ceilings. It features fine carvings on the gable elevations and at row level. The two centre panels contain the coat of arms of James I, and the arms of Sodor and Man (George Lloyd was Bishop of Sodor and Man before he became Bishop of Chester).

George Lloyd was Bishop of Chester from 1605 to 1613. This appears to be his residence. After decay in the 1890s the house was heavily restored by Thomas Lockwood, who redesigned the east house to match the west house. He removed sash windows and introduced mullioned windows. On the east side, he added a flight of steps to the row level.

# 17. North & South Wales Bank

**DID YOU KNOW ?**

The HSBC in Chester was initially called North & South Wales Bank.

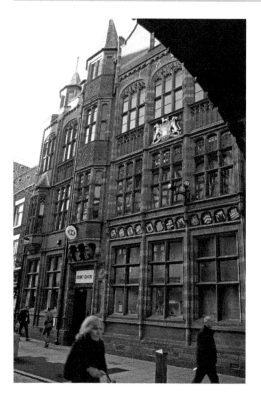

The bank that became the Midland Bank.

This bank was established in 1836. It originated in Liverpool, then opened its doors in Chester in 1883, at No. 47 Eastgate Street, in a building designed by Douglas and Fordham. The bank obtained a licence covering twenty-two towns in north and mid Wales. Its headquarters were originally in Liverpool. The bankers wrote, 'Liverpool is treated as the commercial metropolis of North Wales.' They decreed that 'most of its shares should be confined to Welsh investors'. By 1900, the bank had branches over most of Wales; it later became the Midland Bank and it is now HSBC.

Presently known as the Grosvenor Club, the building has insignia of the twelve former shires of Wales on a frieze across its frontage, including the three golden eagles of Caernarfonshire, a white castle and chevrons of Glamorganshire.

This building is a testament to the economic and commercial vigour of Chester in Victorian times, and to the presence in Chester of Welsh traders and wealthy individuals.

# 18. The Old Dee Bridge to Handbridge

An attractive, low-slung edifice of seven bays and pointed arches, built of sandstone, is located at Lower Bridge Street, just after Bridgegate. It links central Chester with

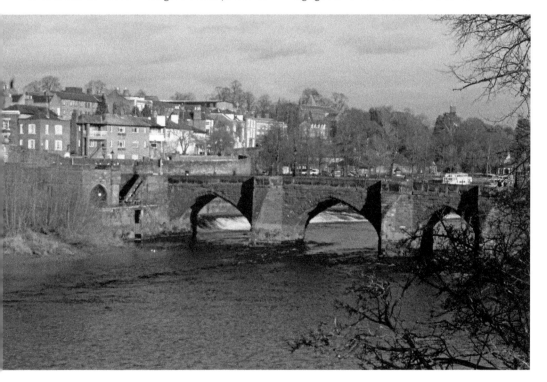

Old sandstone bridge over the Dee to Handbridge.

Handbridge. It is heavily used, with traffic being controlled by lights. It is the oldest bridge in Chester.

The Romans built a bridge here in timber. The present construction was largely created in 1387, is named in the National Heritage List for England and is a Grade I-listed structure.

At this site, in the reign of Lady Aethelflaed of Mercia (AD 911–91), there was a ferry across the river. In 1086 the Domesday Book cited that the Provost of Chester Castle could summon men for the building of Chester and its bridge. Hugh d'Avranches, 1st Earl of Chester (d. 1101), had a causeway built to access it. Repairs to the bridge were instigated by Sir Thomas de Ferrers, Justice of Chester in the mid-fourteenth century. In 1357, Edward the Black Prince ordered that citizens should make improvements to the bridge. In 1367 a murage (a toll for the repair of the town walls) was imposed and the proceeds spent on improving the bridge. As it was the only over-river access point to the city, it was heavily used (as it is today).

The famous Chester architect Thomas Harrison had the bridge widened by the addition of a walkway on the upstream side in 1825. He then proceeded to design the new Grosvenor Bridge, which was officially opened in 1832. He was a remarkable man.

# 19. The Old Harkers Arms on the Canal

Located just below the road between central Chester and the railway station (in Russell Street), with parking on the road, these newly restyled premises are typical of the

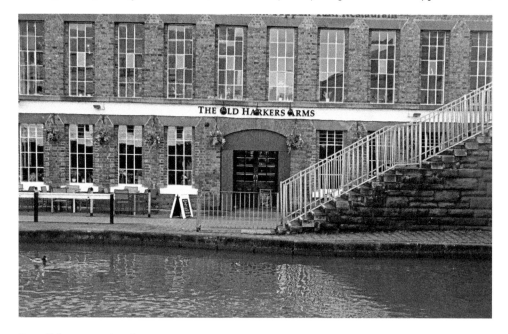

Russell Street canal and restaurant.

Brunning & Price restaurant group. Its walls are covered in old prints and pictures, with tall, book-filled wall units. Its style is pleasantly traditional, with bare wooden floors and old, brown, well-spaced tables and chairs. It serves plates full of food, cooked to a high standard, and is occupied by a committed clientele who enjoy its quiet, well-ordered atmosphere.

It was originally the trading home of Mr Harker and his staff, who were canal boat chandlers – meaning they stocked everything for the trading boats on the canal, from ropes to oars, to waterproof clothing.

The canal outside is the Shropshire Union, a relic of how things used to be in earlier centuries, with goods coming in by water, both by sea and by canal. This area of Chester was equipped with warehouses, which are still there – in their old brick – along this waterway. In 1795 the Ellesmere Canal linked with the Shropshire Union and gave access to Liverpool and Merseyside, with its enormous trade in goods that were imported and exported to and from Britain and the rest of the world.

# 20. The Grosvenor Hotel

Dominating Eastgate, this building is a signature building of Chester as well as a quality setter in its designation as a five-star hotel.

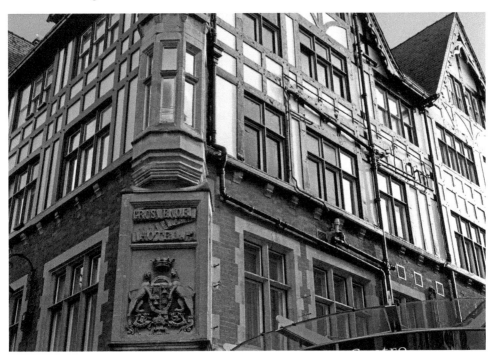

The Grosvenor Hotel.

In the late eighteenth century this was the site of high social activity featuring dancing assemblies and card assemblies, for which subscription gentlemen paid a guinea a week. The Golden Talbot was dubbed 'an ancient and well-accustomed inn' in 1751. It was later demolished to make way for The Royal Hotel, which was purchased in 1815 by Robert Grosvenor, then Earl Grosvenor (later the 1st Marquis of Westminster).

In 1863 Thomas M. Penson was charged with creating a new design; this featured a ground-level colonnade. The name was changed to the present one: The Grosvenor Hotel.

This distinguished hotel has many interesting features, including a painting of 1875 by Charles A. H. Lutyens, the father of the famous architect. A stairwell contains a chandelier bought from London's Junior Carleton Club in 1966 for £15,000. It contains 28,000 pieces of crystal glass and weighs half a tonne.

# 21. The Gorgeous Crown of St Werburgh Street

Where St Werburgh Street joins Eastgate Street, on the high level, is a row of buildings all presented in the Chester black-and-white style. They are Nos 2–18, built in 1895–97.

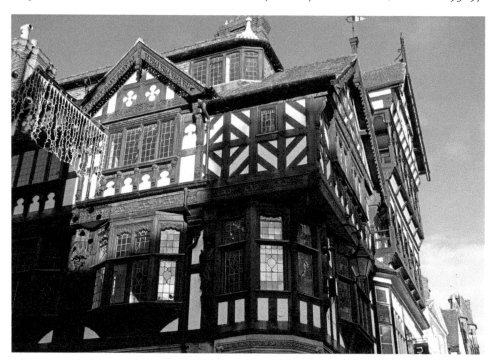

John Douglas's design in St Werburgh Street.

Their origin lies with Chester City Council, which, in 1890, decided to restyle St Werburgh Street by removing a row of shops on its east side. The council intended to sell the spaces as vacant lots to individual buyers, but local architect John Douglas stepped in to buy the entire length of the street. He set about designing and erecting a series of buildings in a matching style – the 'Chester style'. The terrace was completed in 1897 at a cost of over £17,000. The building at the south end, occupied by the Bank of Liverpool, was the first to be completed. A commemorative plaque is attached to the wall on the St Werburgh side, placed by John Douglas's former pupils and assistants.

The elaborate terrace is of three storeys, plus attics. The front has eleven gables. At the north end is a turret with a spire. The upper storeys display 'an unbroken expanse of gorgeously ornamented half-timber'. (Hubbard). Another commentator writes, 'undoubtedly Douglas's greatest work in Chester and the highpoint of the Victorian black-and-white revival in the city'.

Nowhere else in Britain is there a piece of urban revival architecture so bold and beautiful.

# 22. Nos 6–11 Grosvenor Park Road

Close to the entrance to Grosvenor Park is a terrace of houses, outstanding in their tile and terracotta detailing and their tall, spiky character. They are in High Victorian style. They were designed around 1879–81 by John Douglas. It is reported that he bought the plot and financed the building himself. They are extraordinary in their fairy-tale way, showing the use of diapering (patterns with bricks and tiles) and pargeting (decorative plasterwork).

1879 Douglas design, Grosvenor Park Road.

Pevsner writes,

a brilliant group of brick houses. The composition is excellent, varied yet enough of a unity. How much more convincing Douglas is here where the temptation to fussiness inherent in the magpie technique is avoided. The Baptist Church is part of the group.

Did he die a rich man? He had built himself a gorgeous house overlooking the river, however, his grave in Overleigh is extremely modest.

# 23. The Grave of John Douglas

Few have left their mark on Chester more than John Douglas, the architect. He was an expert in the Gothic style and also Tudor black-and-white. His final office in the city was in Abbey Square.

However, his grave is in contrast with this achievement. It lies in Overleigh Cemetery, near the Dee and the Grosvenor Bridge – a simple flat stone carrying the names of John, his wife and children, the last-born of whom (Sholto Theodore Douglas) lived on until 1943. He does not, even for a man of such achievement, have prominence in his own grave – his name is tucked in, in the centre of the list, after the name of his wife. He deserves a memorial monument in or near St Werburgh Street.

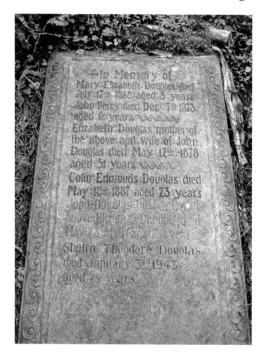

Douglas family gravestone, Overleigh Cemetery. (Picture: Chris Kemp)

# 24. The Eastgate Street Clock

The famous clock in Eastgate Street is called the Diamond Jubilee Memorial Clock and was erected in 1899. It commemorates Queen Victoria's Diamond Jubilee of 1897.

The present arch dates from 1768; there are side arches for pedestrians. It sits on the site of the original Roman entrance into the city. The clock is carried on open iron pylons, and unusually has a clock on all four sides, under a copper cupola. The clock, with its supports, was designed by John Douglas.

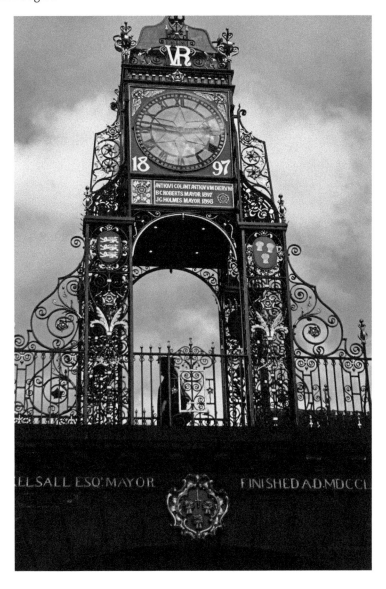

Eastgate Street clock.

In the eighteenth century the city's walls were converted into walkways. The medieval gateways were narrow, obstructing traffic, so they were replaced.

When John Douglas was asked to prepare a design for the new clock, he did it in stone, to the cost of £1,000. But this design was rejected on the basis that it restricted light to nearby properties. He then prepared his light ironwork structure, which was accepted.

The clock was unveiled on 18 May 1899, which was Queen Victoria's eightieth birthday

# 25. Where is the Grave of Mary Jones?

We know it is a common name, but how many women in Chester in the nineteenth century could claim to have given birth to thirty-three children, including fifteen sets of twins? Is this true? Steve Howe of 'Virtual Stroll' reports it and seems to think that it is.

A search through the website of Overleigh Cemetery reveals twenty-seven entries under the name Mary Jones, but not one of them cites a death date of 1899, aged eighty-five.

Mary Jones of the many children.

Mary Jones was a furniture dealer of Foregate Street, Chester. Her husband John died on 24 February 1892, and his wife was buried beside him. At that point ten of their children were still alive.

When a popular magazine of the day, *Tit-Bits*, offered a prize to a woman who was 'judged to have contributed most to the population of the Empire', Mary Jones of Chester was the easy winner!

# 26. The Important Archaeologist

Chester's Roman amphitheatre, and nearby Roman remains, lie there today largely as a result of the pioneering work done by Professor Robert Newstead (buried in Overleigh).

He was born in Newton Abbot, Norfolk, in 1859. In 1882 he worked in the gardens of Ince Hall, Cheshire, for Captain Park Yates. He became involved with the Chester Society of Natural Sciences. Alfred O. Walker was a patron and friend. Robert became curator of the Grosvenor Museum in 1886. He became involved in archaeology and explored sites

Roman remains, discovered by Prof. Newstead.

in Chester, often doing the digging himself. Sites he worked on included Infirmary Field, Deanery Field, Amphitheatre, S E Angle Tower, and Princess Street.

He uncovered the huge outer wall of the amphitheatre and floor, and secured the dating as the first century AD.

He died in 1947.

# 27. Arkle in Chester

The famous Irish thoroughbred bay racehorse was connected to Chester via his owner, Anne Grosvenor, Duchess of Westminster. He was grandson of Nearco, unbeaten in fourteen flat races. Arkle was born in the Ballymacoll Stud, County Neath, named after a mountain in Sutherland, Scotland, that bordered the Duchess's estate. During his steeplechasing career, he was usually ridden by Pat Taaffe.

Arkle the racehorse is associated with the Grosvenor Hotel.

Arkle won three Cheltenham Gold Cups and many other top prizes. He was, following an injury, put down at the early age of thirteen.

The Chester Grosvenor Hotel contains the Arkle Bar and Lounge, which is open daily for cocktails and pre-dinner drinks, except on Sundays and Mondays. Children under twelve are not allowed.

# 28. The Plague

As it did in many of England's oldest cities, the plague spread its deadly fingers into Chester a number of times.

The Black Death of the fourteenth century visited Cheshire in 1348, which was an abnormally wet year; harvests suffered, as did the diet of poor people. Deaths were common and farms suffered because of the absence of labour.

In 1507 the 'sweating sickness' visited Chester and ninety-one people died. In 1517 the plague came and 'for want of trading the grass did grow a foot high at the Cross and in other streets'. In 1558 the plague hit Chester and many went into the countryside to

The plague ran all through Chester.

escape it. It came again in 1574, and the precaution was taken of prohibiting citizens from accepting lodgers from plague-present locations.

In 1603, 650 persons died of the plague in Chester, starting in St John's Lane. Michaelmas Fair was cancelled. Infected people were removed from their homes and rehoused near the river. In 1604 over 800 persons died.

A small museum, under the title 'Sick to Death', is located in the water tower on the city walls. There is an entrance fee.

# 29. The Public Baths

These baths are on the north side of Union Street, at its junction with Bath Street. Designed by John Douglas and built in 1898, they are housed in a Grade II-listed building.

The Chester Swimming Association has stewardship of the baths. Over 2 million pounds was recently spent on improving the facilities. Maintenance costs over £16,000 a year.

Swimming lessons are offered in the two large heated pools, one called Pacific and the other called Atlantic.

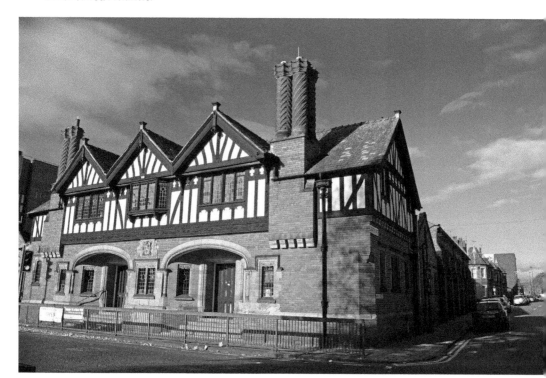

The Public Baths, Union Street.

# 30. Thomas Hughes (1822–96)

Hughes was called to the Bar in 1848, becoming Queen's Counsel in 1869. He became a county court judge in Chester in 1882. He had a strong social conscience and was linked with Christian socialism. He died in 1896.

In 1912 his daughter Lilian perished in the *Titanic*'s sinking.

Thomas Hughes,
author of *Tom Brown's
Schooldays*.

# 31. Nos 2–8 Bridge Street

Thomas M. Lockwood achieved a triumph of contrast at the head of Bridge Street, at the Cross. He created an extraordinary black-and-white building at the corner of Eastgate Street. This building has the unusual appearance of bending itself around the corner, including the row, and yet having stature and coherence.

On the opposite corner, at the beginning of Watergate Street, Lockwood created an eclectic exercise in decorative Ruabon brick and yellow sandstone, incorporating Tudor, Jacobean and baroque features. This Watergate/Bridge Street building is an exercise in different styles effectively brought together. It was built for the 1st Duke of Westminster, in 1894.

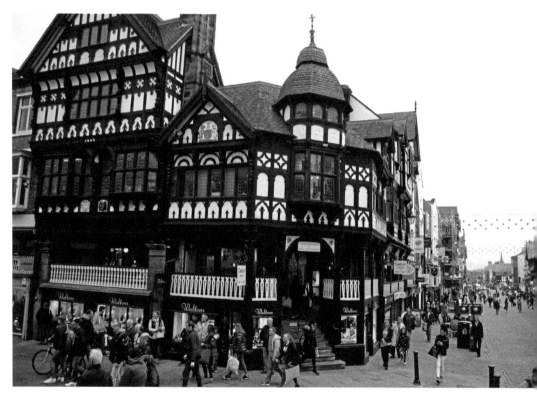

Corner of Bridge and Eastgate streets.

# 32. The Old Fire Station

**DID YOU KNOW ?**

What is now Chez Jules restaurant in Northgate Street was previously the Chester Fire Brigade HQ.

The fire station on the west side of Northgate Street (No. 73) was newly created in 1911, with three arched entrances and elegant rounded windows amid half-timbering.

Old cottages in Valentine's Court (now Firemen's Square) behind the station were replaced in the 1920s with six firemen's cottages and a superintendent's house fronting

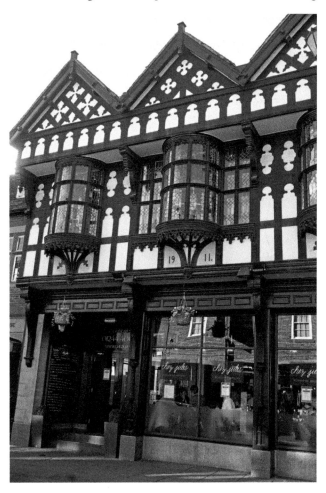

Originally the fire station.

Northgate Street. A ghost called 'Firemen Jack' is said to appear, dressed in an old-fashioned fireman's uniform with a brass helmet.

The first motorised fire engine was bought in 1914. In 1950, a motor appliance was bought from John Morris & Co. of Manchester, costing £1070. It carried a 50-foot escape ladder and a 600-gpn pump. The Northgate Street station was replaced in 1970 by a new station in St Anne's Street.

The site has been occupied since the mid-1990s by Chez Jules, a popular French restaurant.

# 33. Daniel Craig (James Bond)

Liverpool Street house.

One of the most successful, and wealthiest, of modern British actors was born in Liverpool Road, Chester, on 2 March 1968.

Craig is an alumnus of the National Youth Theatre and graduated from the Guildhall School of Music and Drama in London. He began his career on stage but achieved fame when he was chosen as the sixth James Bond, taking over from Pierce Brosnan in 2005. *Casino Royale* enjoyed the biggest early success. *Quantum of Solace* came two years later. *Skyfall* was released in 2012 and has taken the most box office money of the series so far. It is the fifteenth highest-grossing film of all time.

Craig made a guest appearance at the opening ceremony of the 2012 Olympic Games in London, appearing alongside Elizabeth II.

# 34. The River Dee

The River Dee at Chester.

The River Dee is a long river, some 70 miles, flowing from Wales into England, at times forming the border. It discharges into the sea between the Wirral Peninsula and north-east Wales. Historically, it was the boundary of the kingdom of Gwynedd. In Welsh, it is 'Afon Dyfrdwy'. It passes through Bala Lake, then passes Corwen and Llangollen. It flows under Thomas Telford's spectacular Pontcysyllte Aqueduct (the 'Stream in the Sky') of 1805, which carries the Llangollen Canal 120 feet overhead.

Near Eaton Hall, the seat of the Duke of Westminster, the Dee passes into England, and widens as it flows through Chester. Flowing under the Grosvenor Bridge, it swerves around the Roodee racecourse. This area was once a Roman harbour, until the river silted up. It then underflows Chester's fourth bridge, carrying the railway. This was the site of the first railway accident in the country, the Dee Bridge disaster.

West of Chester, the river flows along an artificial channel, excavated between 1732 and 1736, the location of Connah's Quay. This work was overseen by engineers from the Netherlands. The channel goes on for 5 miles.

Chester was, at one point, a major port. It imported and exported goods and people, especially to Ireland. Watergate Street is named after goods being taken to and from the port on the Dee.

# 35. Old Custom House Inn, No. 69/71 Watergate Street

Originally two houses with undercrofts, now combined into one, this building is an echo of how Chester used to be when it was a busy port. The older east side is dated 1637, with the west side some seventy years younger. It was originally the Star Inn, but it changed its name because the custom house of the port of Chester stood close on the same side. This house, now on the corner of Nicholas Street, dealt with goods entering and leaving the port nearby on the Dee.

The eastern section is built on handsome sandstone blocks, above which are two storeys in timber frame and black-and-white. Between the storeys is a breastsummer (a beam over a shopfront) with carvings of vine leaves, grapes and the initials 'TWA'. The inn's interior displays oak beams dating from the early seventeenth century, and an attractive carved-stone fireplace.

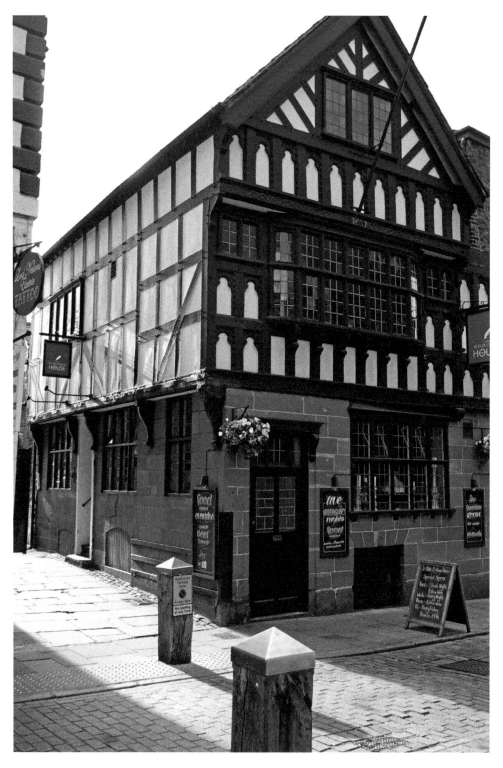

Old Custom House Inn, Watergate Street.

# 36 The Dublin Packet, No. 27 Northgate Street

This is another memory of when Chester was a busy port. A 'packet' is a sailing vessel, usually carrying passengers. Such a ship would make the Chester–Dublin run regularly with paying passengers.

Northgate Street afforded access to the nearby wharf on the Dee for passengers taking the regular sailings to Ireland and elsewhere. This pub would be well placed for accommodation and food.

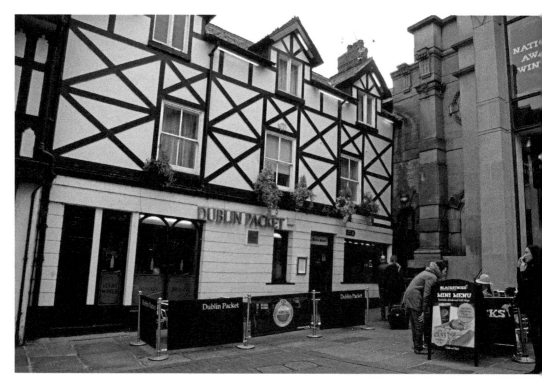

The Dublin Packet, near the Town Hall.

# 37. Northgate

In 1808 Thomas Harrison was given the commission to design a new gate for the northern access into the city. This was at the suggestion of Earl Grosvenor, mayor of Chester in 1807. There were three other gateways – Eastgate, Bridgegate and Watergate – which had been replaced in the eighteenth century. The city walls ran over these. The earl was an enthusiast for the Gothic style, but Harrison argued that this would make the structure over-elaborate and out-of-period, so he pressed for a neoclassical design, in keeping with the adjoining city walls. He made a design of three arches, with vehicle access in the centre and two narrower arches on both sides for pedestrians – these incorporate a pair of monolithic, unfluted Doric columns.

Built of pale-red sandstone ashlar, there are inscriptions on both sides, one naming Thomas Harrison as architect.

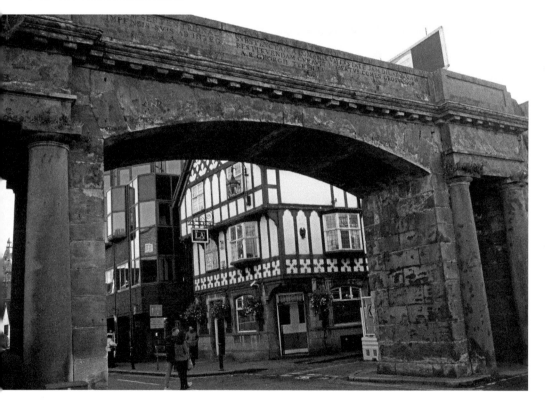

Northgate archway, by Thomas Harrison, 1808.

# 38. The Architect

**DID YOU KNOW ?**

The new restaurant The Architect was designed as a home for the architect Thomas Harrison.

When Brunning & Price (of The Restaurant Group) took over a building and plot at Nicholas Street, Chester, close to the Roodee and the Grosvenor Bridge, they set about remodelling and rebuilding. The result is a building fitted out in the style of the nineteenth century, a short walk from the centre of Chester. It is popular with diners seeking a refuge in a traditional setting.

It was originally St Martin's Villa, and the land on which it was built by Thomas Harrison was presented to him by Cheshire County in gratitude for his loyal and devoted service. In 1820, Harrison completed his design for his new home, moving from his former home: Follot House in Northgate Street. He also completed the design and rebuilding, on the nearby Chester Castle site, of his master work – now the Crown Court building, barracks,

The Architect restaurant.

and propylaea (imposing entrance archway). His triumphant design for the Grosvenor Bridge was not completely constructed when he died in 1829.

For his new home, Harrison's design was that of a simple villa. 'It adopts a conventional classical form, influenced by Roman villas and Palladio's villas of Northern Italy, which Harrison would have studied on his European tour, and the overall effect is certainly pleasing to the eye and harmonious ... The building has very little in the form of ornamentation – there are no cills or lintels, for instance, or Doric columns to the entrance, and similarly the interior is almost minimalist in its lack of unnecessary decoration.' (B & P website)

In later years, the house and plot were described as being part of St Martin's parish, and a rectory.

# 39. The Pied Bull

The Pied Bull is said to be the oldest licensed premises in Chester, dating back to the eleventh century. It attests to the age of Northgate Street, and in the sixteenth century it was known as Bull Mansion. It was a coaching inn, and in 1784 a 'coach-and-four' (meaning a carriage on wheels capable of carrying at least six passengers drawn by four strong horses)

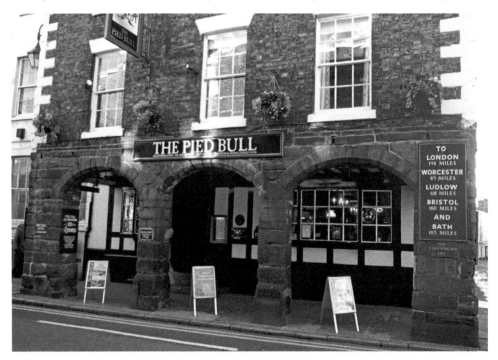

The Pied Bull pub in Northgate Street.

ran regularly from here, using its stabling facilities. In 1854 George Borrow stayed here before his tour of Wales, which was published (and still remains in print) as *Wild Wales.*

The handsome wooden staircase, which is still there, was installed in the mid-fifteenth century. Inside the building there are tall fireplaces, wooden panelling and oak beams.

Regarding ghosts, the usual story is of a lady wearing a grey cloak. Rooms 8, 9 and 19 are indicated for sightings.

# 40. Chester's Coat of Arms

## DID YOU KNOW ?

Chester's coat of arms featured three sheaves of corn, introduced in 1181.

The design goes back to Hugh d'Avranches, 1st Earl of Chester, in 1070. It was 'Azure [light blue] a wolf's head, argent [silver]'. The 4th Earl of Chester introduced three gold sheaves in 1181.

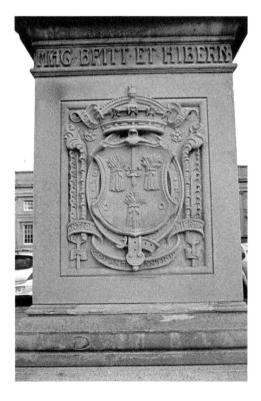

Chester's coat of arms.

The present arms of the city of Chester have been in use since the fourteenth century. The shield shows three lions on the left in red, with a sheaf, and half a sheaf on the right in gold and blue. Supporting this on the dexter side (left) is a rampant lion in gold; on the right (sinister) is a white wolf wearing a gold crown.

The shield represents the royal arms of England (a red shield with three gold lions) and those of the Duchy of Chester – three gold sheaves on blue. The supporters are the golden lion of England and the silver wolf of Hugh Lupus, 1st Earl of Chester.

The caption reads, 'ANTIQUI COLANT ANTIQUUM DIERUM' – 'Let the Ancients Worship the Ancient of Days'.

# 41. Admiral of the Dee

Since 1528, the mayor of Chester has carried the title of the 'Admiral of the Dee'.

In March 1992, Elizabeth II granted the title 'Lord Mayor of Chester'. The office of Sheriff of Chester dates from the early twelfth century. Both these titles are honorific and granted by Chester city councillors annually. Councillors are voted into office by citizens (ratepayers) of the city.

The old custom of 'Admiral of the Dee'.

# 42. The Old Port: Building the *Royal Charter*

## DID YOU KNOW ?

The ship *Royal Charter*, built on the Dee, sank off Anglesey, carrying gold from Australia.

In the early nineteenth century trading and shipbuilding were prevalent in Chester. The Watergate Area and the Old Port are described here by J. H. Hanshal, editor of the *Chester Chronicle*, 1816:

Beyond the Watergate and Crane Street and Paradise Row, the whole of which lead to the wharf on the river, for a number of years Chester has carried on an active trade in shipping and ship-building. … It is not unusual to see ten or a dozen vessels on the stocks at a time. In fact there are as many ships built in Chester as in Liverpool,

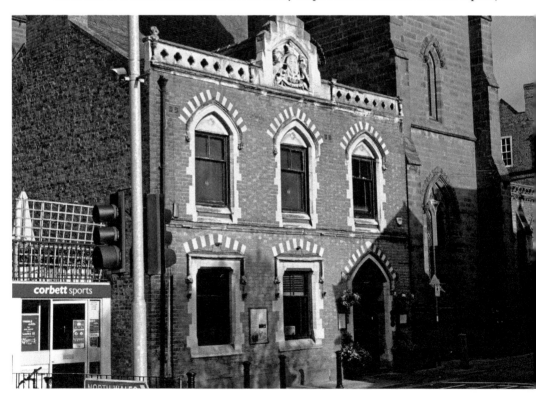

The old Merchant's House building.

and the former having a preference for the merchants. Chester lies convenient for the trade, as by the approximation of the Dee, timber is every season floated down the almost exhaustless woods of Wales, at trifling expense and without the least risk. ... There are almost 250 hands employed in the business. Six vessels of war have been built and in the last two years (1814–5) two corvettes and two sloops of war ... from twenty to thirty guns each.

In 1810, more ships were built along the Dee than at the port of Liverpool, on the Mersey. One ship built here was the *Royal Charter*, a steam ship that sank off Anglesey in 1858. Many souls perished and much gold was lost. The wreck has been explored by divers and many rings have been made from gold taken from it.

# 43. 2nd Marquess of Westminster

In the centre of Grosvenor Park stands an imposing white-marble monument to this 2nd Marquess (1795–1869). He enjoyed four titles: 2nd Marquess of Westminster, The Honourable Richard Grosvenor, Viscount Belgrave and Earl Grosvenor.

Born in London, educated at Westminster School and Christ Church, Oxford, he was elected MP for Cheshire until 1832 and then for South Cheshire. He was presented with

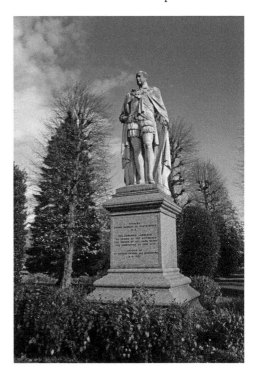

Statue to the 2nd Marquis of Westminster.

The Order of the Garter in 1857. He extended and improved his London properties and bettered his assets in Dorset and Cheshire, building and supporting farms, schools and houses. He supported churches and patronised Chester architect John Douglas. He gave fields in the middle of Chester to the city council for the formation of Grosvenor Park and financed the entrance lodge, designed by Douglas. The statue to his memory was erected in 1869.

Lord Westminster and his wife had thirteen children. Their second son, Hugh Lupus Grosvenor, succeeded him as 3rd Marquess; he was later Duke of Westminster. His obituary in *The Times* read, 'he administered his vast estate with a combination of intelligence and generosity not often witnessed'.

His wealth was, in today's money, valued at over 66 million pounds.

# 44. Watergate House

This outstanding building is on the left as one proceeds down towards the end of Watergate Street. Designed by Thomas Harrison in 1820, it was once of the largest private house in the city. It is now occupied by separate businesses.

House in Watergate Street.

Its heart is the remarkable front entrance, all curves flanked by two Doric columns. The lobby is circular, containing three curved doors that split in the centre – an unusual design. The entrance hall is square, lit by a lantern.

This is probably the most striking and original design of a private residence in nineteenth-century Chester; there is no trace of the Gothic or black-and-white. One could say it was 'modern' and shows remarkable forward-thinking for its time in 1820. Its spaces are Georgian but it could easily have been designed in the 1920s

# 45. Grosvenor Park

Grosvenor Park is a wonderful place – wide open, clean, well cared for, and beautiful.

Overlooking the Dee, it is almost certainly the best Victorian park in the north of England.

Its secret is that it is not overdone, not too much greenery; it is generous in grass and so in long views. It is Grade II* in the National Register of Historic Parks and Gardens.

The park keeper's lodge now houses the city council's parks and gardens office. The building is by local architect John Douglas and is his first use of black-and-white facia. On the upper storey are eight carvings of William the Conqueror and the seven Norman earls of Chester.

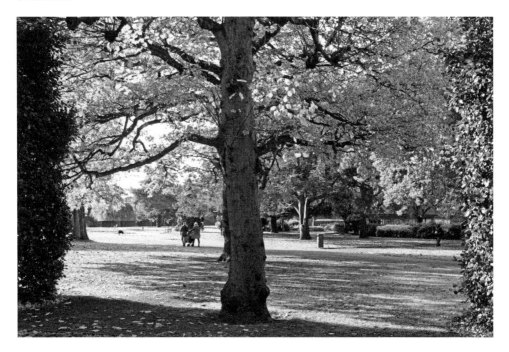

Grosvenor Park, central Chester.

Billy Hobby's Well is reputed to have magical properties. There is a drinking well known as Jacob's Well, and in the park there are three medieval arches, removed from elsewhere. St Mary's Arch is from the thirteenth century.

Near the lodge are Roman earthenware pipes, originally used to carry water to the garrison in the city centre from Boughton.

A summer music festival is held in the park.

The Grosvenor Park Miniature Railway was laid down in 1996 to commemorate the centenary of the Duke of Westminster's railway at Eaton Hall. It has a gauge of 7.25 inches and a length of 0.25 miles – excellent for children.

The summer months see activity at the Open Air Theatre, where a Chester-based professional theatre group performs. Art in the Park is a popular summer event, as is the annual prize-giving for Chester in Bloom and allotments competition.

# 46. Oddfellows

On the right in Bridge Street, Oddfellows is an imposing Georgian-style tall, square building with, unusually for a hotel, a flight of steps up to the lobby and reception. The next space comprises the kitchen, lounge, dining space and an upright, wide bar. The décor

Oddfellows hotel and restaurant, Lower Bridge Street.

is without modern stripping; it is semi-Victorian, lounge-like and relaxing. It has regular locals as customers for meals and has a homely feel. Some of its bedrooms are in an annex at the back, over the garden space, which has multiple seating areas that are much enjoyed on warm summer's day.

Oddfellows offers afternoon teas with a short historical introduction. We are told that Anna, the 7th Duchess of Bedford, introduced the event in her home in 1840. The tea selection includes peppermint, rooibos, lemon and ginger, Earl Grey, etc. Cocktails include Three Tiers, A Trace of Odd, Purple Haze, Mrs Grey, etc.

# 47. The Queen's Hotel

This is another (after the Chester Grosvenor) local hotel of size designed by the remarkable Thomas M. Penson.

Facing the city railway station, it was intended for travellers who came and went by rail. It was opened in 1860 and welcomed celebrities such as Charles Dickens, Cecil Rhodes and Lillie Langtree. It has 218 bedrooms.

The Queen's Hotel, opposite the railway station.

Beautifully styled, its hall has a colonnaded entrance and a magnificent suspended staircase. It has a spa treatment centre, a garden, and a licence to hold civil ceremonies. It has meeting rooms, banqueting and wedding suites. There is hotel parking.

The Queen's Hotel is a fine example of the nineteenth-century boom in railway hotel building.

# 48. Hickory's

Hickory's is an unusual restaurant, described as a Smokehouse and located next to the Dee. It has extensive outdoor seating, as well as often-booked internal tables. Sitting in the upright chairs, one can see the flames rising from the metal grill and the meat being carved, so as to be hot to the plate. Hamburgers are especially popular.

At its heart, in the kitchen, is the 'smoker'. This device was specially imported from Missouri. The brisket requires over fifteen hours of smoking. Popcorn is free, as is the stout bottle of water.

The owner writes,

A 2009 road trip across Texas and Louisiana ignited a passion to bring home the flavours, culture and hospitality of the Southern States. A year later the first Hickory's

Hickory's restaurant, on the river.

Smokehouse opened in Chester with the aim of pioneering authentic Southern-style barbecues this side of the Atlantic. Every year or so we return to the region to look for inspiration and pinch an idea or two. We ship our wood for our smokers direct from the USA.

# 49. The London Camera Exchange

These premises at No. 9 Bridge Street Row (near the corner with Eastgate Street) have been specialising in photography for decades. It is a pleasure to experience a genuine camera shop.

If you wish to graduate from the limited experience of a mobile phone camera to a Single Lens Reflex (SLR), which will give you many more settings to capture shots capable of being enlarged in sharpness to poster size, this is the place to come.

It's unusual. Specialising in Canon products, a reasonable payment will allow the purchase of a used camera with an extra lens. Their advice is objective and trustworthy.

Now that the digital system of photography is well established, amateurs can, with a little practice, produce photographs of remarkable impact, and they can be successfully printed on paper at home.

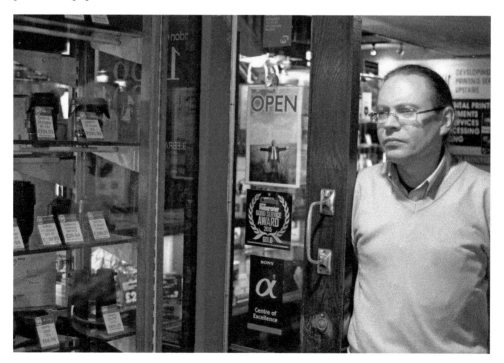

The London Camera Exchange shop on The Rows.

# 50. The Old Boot Inn

This Old Boot Inn, The Rows, at the busy end of Eastgate Street, dates back to 1623. It competes with others for the title of 'the oldest pub in Chester'. It is certainly much liked, having dozens of 'regulars'. 'Time gentlemen, please' is called at 11 p.m.

The pub's seating area (parlour) shows a seventeenth-century wainscot. In the mid-eighteenth century the row level was a barber's shop, and the pub was accessed down a corridor.

It has a ghost – female groans and shots are heard. It is reported to have been a brothel.

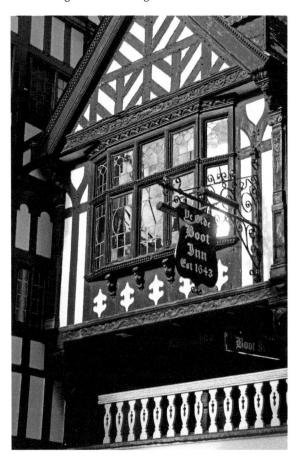

The Old Boot Inn in Eastgate Street.

# 51. Ye Olde Kings Head

Originally from the thirteenth century, with pub use coming later, this building's later additions include (it is alleged!) timber beams and pillars from Admiral Nelson's sunken ships.

This inn is located at No. 48 Lower Bridge Street, on the right facing the river, at the bottom, on the corner of Castle Street. It is a Grade II-listed building. It was built for 'Peter the Clerk', administrator for Chester Castle. Originally erected in 1208, it is timber-framed, finished in yellow sandstone, with rendered brick. It has three storeys, with three bays on each face. The bays on Lower Bridge Street are gabled.

It has accommodation and is praised for its food and drink.

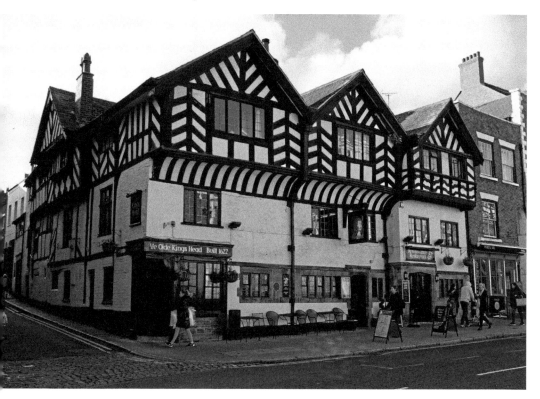

Ye Olde Kings Head pub in Lower Bridge Street.

# 52. The Rows

Why The Rows are in Chester and nowhere else is a good question; the explanation is not entirely clear. They must be linked to a peculiarity in the early history of the city.

Two elements seem to apply: residences in the town centre and trading.

If we go back to the Middle Ages, we find that town streets were primitive in their surfacing. Before streets were surfaced with stone and cobbles, the surface would be bare earth. When wet, this turned into mud and any adjacent residence would have dirt carried into it, causing distress to the occupants – the floors would be impossible to keep clean.

It therefore made sense to set residences above, and yards away from, the edge of the road. So the 'row' was born, which was kept dry by having the residence built over it,

The Rows in Bridge Street.

giving access from the road up steps with an open-to-the-air side. It also allowed its inner elevation to work as a shop, selling the trader's stock to the public.

Secondly, traders: Chester was a very business-like city, known for its gloves. But many other trades were engaged in this business too. The gloves were carried to their destinations by horse and cart, and abroad via the port of Chester and the navigable River Dee, with Ireland reached from here via the port of Dublin. Liverpool, Bristol and London were also reached by ship.

Traders were usually financially well-off. They could afford to buy homes in the city centre, so they did, and when they secured storage space for their stock, simplicity and utility caused their stock to be stored close to their home. This meant they stored it underneath their home and the concept of the undercroft was born. It is similar to a cellar but not quite the same. The undercroft would have access horizontally onto the main road, where carts to carry goods would be drawn up. The traders might well have needed more storage space, so they dug down and created a cellar, which in some cases had access down steps from the road edge and in other cases had steps rising to the undercroft above.

# 53. The Bear & Billet

This imposing building at the bottom of Lower Bridge Street, close to the river, with its impressive multiple-pane wide window, dates from 1664.

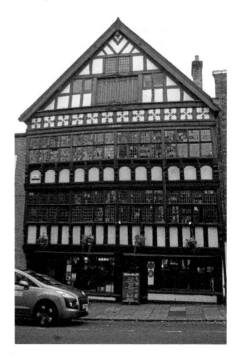

The Bear & Billet pub, Lower Bridge Street.

It was the townhouse of the Earl of Shrewsbury. He was a tax collector at the south gate in the seventeenth century.

The earl's bailiff was an unpleasant man. He is supposed to have closed a young woman in an upstairs room without feeding her. He left her in the room when he travelled to Shrewsbury, and the young lady died. Her ghost haunts the upper floor; cries are heard and appliances are turned on and off. Moving figures apparently haunt the upstairs kitchen. Also, things are said move in the office and windows are opened.

A drawing of 1820 has it as the Bridgegate Tavern; its present name came soon after. Today it is a popular restaurant, serving a range of traditional hot meals.

John Lennon's grandmother, Annie Jane Millward, was born in this building in 1873.

# 54. The Falcon

One of the most striking buildings in Chester, The Falcon occupies a corner site in Lower Bridge Street, where it joins Grosvenor Road. It is a Grade I-listed building, and an example of good seventeenth-century timber framing (1626), above an earlier base incorporating a thirteenth-century crypt. A row once ran through this building.

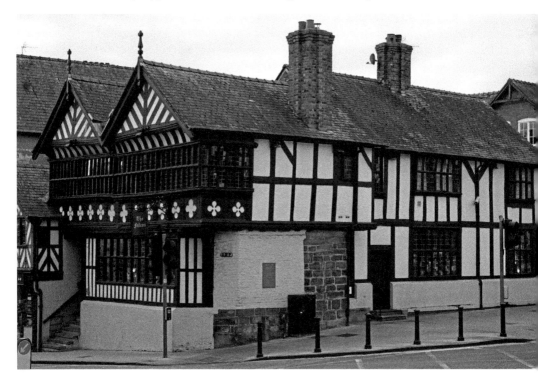

The Falcon pub, Lower Bridge Street.

This was formerly a house dating back to around 1200. It has a great hall that was added later, running parallel to the street. It was substantially altered during the late sixteenth and early seventeenth centuries. The medieval undercroft is now used as a beer cellar.

Sir Richard Grosvenor purchased the property in 1602. During the English Civil War he left here and moved his family into Eaton Hall.

In 1879 alterations were made by John Douglas and it traded as The Falcon Cocoa House. The building had become rundown in the 1970s, so The Falcon Trust was established and the building was donated to the trust by the Grosvenor Estate.

# 55. The Cathedral Bell Tower

**DID YOU KNOW ?**

The only bell tower in Britain to be built outside a cathedral since the Reformation is in Chester.

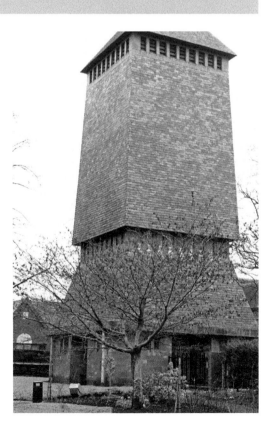

The cathedral bell tower.

This is a unique structure, a detached cathedral bell tower, named Dean Addleshaw Tower after the dean of the cathedral, who arranged its building. It is situated close to where St Werburgh Street takes a sharp bend heading towards Eastgate Street.

In 1963, the original bells were in need of refurbishment but the architecture of the building did not lend itself to the stress of replacement. It was decided to place them elsewhere outside the main building in the south-east corner. Recast by John Taylor & Co., the ring of twelve bells with a flat 6th were hung in the new tower. They were first rung in February 1973.

Two original old bells, from 1616 and 1626, were left within the building.

Built in concrete and surfaced with light-grey slate, the tower is based in sandstone. It is the first UK detached cathedral bell tower to be built since the Restoration.

# 56. Thomas Harrison's Propylaeum

Between Grosvenor Road and the Castle Square stands Thomas Harrison's last-designed building. It is a huge entrance or gateway with two rows of Doric columns. In the modern

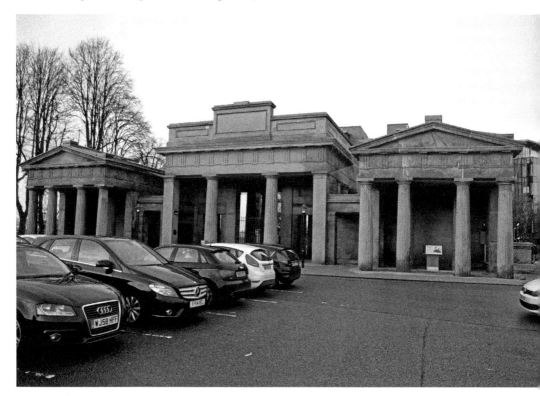

The entrance to the Court House.

context it seems out of scale, but when Thomas Harrison created it, he put behind it a huge development that consisted of barracks, a law court, prison and suchlike, all built in monolithic Greek and Roman style. Perhaps he wished to echo the style and ambitions of the Romans, who originally occupied central Chester. The colonnades to both sides of this entrance, connecting with pavilions, presented a gigantic presence, grandeur for those entering and leaving the city.

The two pavilions were designed as guardhouses. The central block is extended some 10 feet in front of the pavilions. The columns are 18 feet tall; there is a frieze and a raised tablet above. The gateway colonnades and wings above all have stone coved ceilings. Mordant Crook writes in his book *The Greek Revival,*

[it combines…] direct antique inspiration – the Temple of Philip at Delos and the so-called Temple of Augustus in Athens – with the primal simplicity of the Sublime and the variety of light and shade associated with the Picturesque.

Pevsner writes of the whole civic buildings of the Chester Castle site:

What Harrison has achieved here is one of the most powerful monuments of the Greek Revival in the whole of England.

# 57. Three Old Arches, No. 48 Bridge Street

**DID YOU KNOW ?**

The Three Old Arches in Bridge Street is said to be the oldest building in Britain incorporating a retail shop.

This is a very old building, originally constructed in the thirteenth century, including original cellars. In the fourteenth century it was extended to the south when the hall, adjacent to The Rows, was built. It was the largest private residence originally set in The Rows.

William Jones, a grocer, used the building in the twentieth century. It was then used by Owen Owen, a department store, which closed in 1999.

The date AD 1274 is inscribed on the façade between the arches. The stone wall of the shop at street and row level is considered to be the oldest surviving building in England incorporating retail premises.

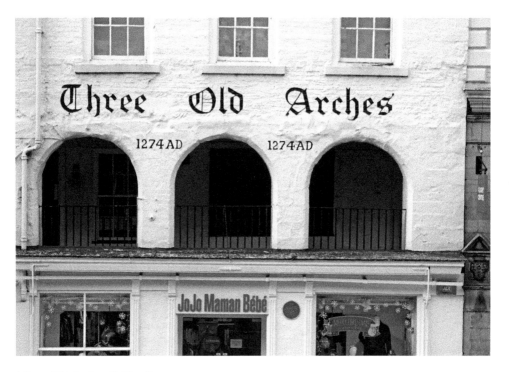

Three Old Arches, Bridge Street.

# 58. Chester USA

The high number of places called Chester in the USA indicates the depth of population and socio-economic development in our original Chester.

Chester, Pennsylvania, is a city in Delaware County with a population of around 34,000. It is situated on the Delaware River, between the cities of Philadelphia and Wilmington. Settled by the Swedes in 1640, in 1682 William Penn arrived by river in his ship *Welcome* and renamed the settlement after Chester, England.

Chester's naval shipyard has been active in shipbuilding and repairing; this was utilised by the Ford Motor Co. In 1990 the shipyard closed, leaving a legacy of two ships of the US Navy named *Chester*. In the history of rock 'n' roll Chester is prominent, for Bill Haley and The Comets first played there, and had their headquarters there.

Chester, Penn, USA.

# 59. The Romans

In this picture a town guide wears a facsimile of Roman military regalia. He and his colleagues are often to be seen leading a trail of young schoolchildren through the Chester streets, the children proudly holding copies of Roman shields.

The story of the Romans in Chester underpins the development of the city through the last 2,000 years. The design of the city was theirs, including the walls and the central streets. The Romans accessed Britain in AD 43. It took them thirty years to reach Chester and they called it Castra Deva ('the military camp on the River Dee'). It was the base for the 20th Legion (*Valeria Victorix*) for some 200 years. A Roman leader here was Julius Frontinus; the main occupation of Chester took place during AD 73–78. It was abandoned in AD 383.

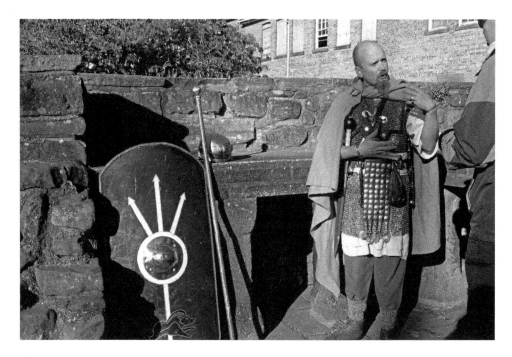

The Romans.

What is now the Racecourse (Roodee) was the location of their harbour. Materials were imported and exported along the Dee, especially lead and copper from the mines and stone from the quarries of north Wales. Some of these goods were carried to the farthest parts of the empire. Viewed from the Roodee, parts of the original Roman quay can be seen at the foot of the medieval walls. The grid-designed Roman fortress extended towards the Dee and came up to what is now called The Cross. Here main roads led in four directions from the *principia*, the headquarters building. Close to here was the *basilica*, a hall where the legionaries gathered to hear announcements about planned expeditions.

For most of 300 years, the Roman fort at Chester was one of their most important military bases; some historians say that it was the HQ for the Romans in Britain.

# 60. Agricola Tower

Situated on Grosvenor Street, the tower is only accessible by means of a pre-booked tour; children enter free. It is administered by English Heritage.

The Agricola Tower is in the Inner Bailey, accessible through an archway at the far right-hand corner of the parade ground. Ahead is Napier House, built in 1830 as an armoury and barracks. In the guardroom there is a display of the history of the castle. Beside Napier House is Agricola Tower, which derives from the twelfth-century; the blocked passage arch

is still visible. The tower is now a Grade I-listed building. Built of sandstone ash metal roofing in three storeys.

The chapel of St Mary de Castro sits on the first floor, with fine wall paintings. The chapel was used as a gunpowder store, hence the heavy copper door from the early nineteenth century.

The stairs are well worth climbing for they reveal the location of the original castle in the city of Chester. A gun platform was built here in 1745 as a defence against the Jacobite rising of Bonny Prince Charlie.

Going back down to the Inner Bailey, the 'motte', or mound, of the original castle is visible. The square flag tower is medieval.

Agricola Tower.

# 61. Chester Castle

## DID YOU KNOW ?

Chester Castle was founded by William the Conqueror in 1070.

Chester Castle was the administrative centre of the Earldom of Chester and the centre of administration of the County Palatinate of Cheshire (a way in England of moving power away from London. Lancashire was such, controlled by the Earls of Derby – West Derby, Merseyside).

It was a timber motte-and-bailey construction standing on a Saxon fortification. Later, it was rebuilt in stone and the outer bailey added. In 1265 it was held by Simon de Montfort and his supporters against Prince Edward, Henry III's son. It stands on a hill overlooking the River Dee, in the south-west of the territory, bounded by the city walls. It is now only fully visible from the river side.

In the periods of Henry III and Edward I the castle was the headquarters for armies sent to overcome the Welsh.

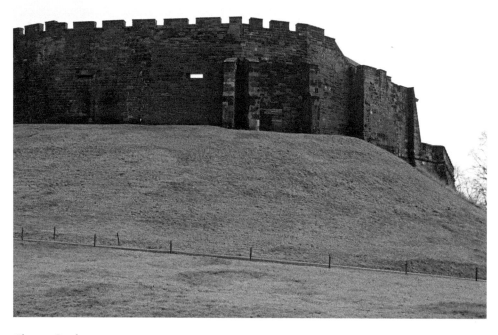

Chester Castle.

In the English Civil War of 1642–46 it was held by the Royalists. Between 1788 and 1813 the outer bailey was completely redesigned by Thomas Harrison in neoclassical style. He won a competition in 1785 for the creation of a new prison, law court, barracks, armoury and county hall. Building went on from 1788 until 1822. The building left there now serves as the County Court and a museum, accessed by the massive entrance archway, the Propylaeum.

In the courtyard is a statue of Queen Victoria, dated 1903, by Pomeroy. The statue of the soldier on horse at the front is of Field-Marshall Viscount Combermere, by Marochetti, 1865.

# 62. Amphitheatre

Built in the first century AD, it was in use until the 120s AD, then used as a rubbish dump. At this time, the 20th Legion was in the north building Hadrian's Wall.

In the third century, it was brought back into use but was abandoned around AD 350. It was not until the 1950s that the full extent of the feature was revealed: it had been used by the Romans for entertainments and for the troops to practise. Less than half the original oval building is now visible. The outer wall is 9-feet thick, marked by slabs in the grass. Stairways took spectators up to the seating area. The arena floor was 3 feet below ground level. A room at the back contained an altar dedicated to the god Nemesis.

The full purpose of their amphitheatre is still being investigated by historians of the period.

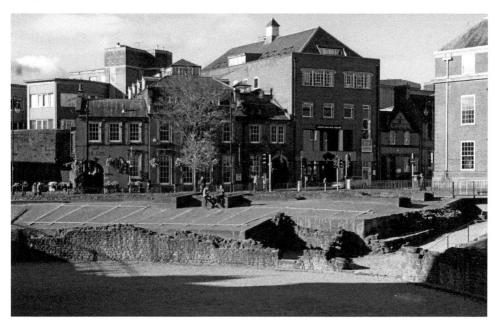

Roman amphitheatre.

# 63. Chester Zoo

Established in 1931 by the Mottershead family, its secret is its size and the wide range of varied animals – a perfect family day out. It is one of the UKs largest zoos at 125 acres – it has a total landholding of 400 acres, but some of this is used to grow food for its herbivorous animals. It is the UKs most visited wildlife attraction, with over 1.6 million visitors a year. In 2007 *Forbes* periodical described it as one of the best fifteen zoos in the world. In 2015 it was described as the best zoo in the UK.

The founder, George Mottershead, was wounded in the First World War and spent several years in a wheelchair. He had a market garden business near Crewe, and started collecting exotic animals. He determined to have his own extensive collection, buying

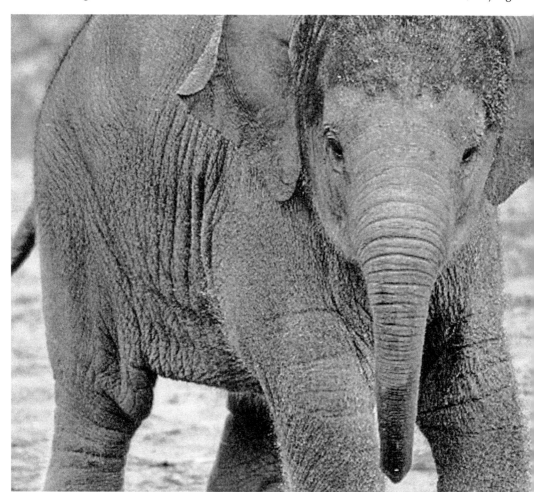

Indali, locally born elephant at Chester Zoo. (Picture courtesy of Chester Zoo)

Oakfield Manor, Chester, for £3,500 in 1930, which included 9 acres of gardens. A polar bear exhibit (1950) was built of wartime roadblocks and pillboxes.

Chester is a supreme example of a zoo without iron bar cages; instead moats and ditches enclose the animals. The chimp island was created when no one knew if chimps could swim – they cannot, so the water surround is effective.

The zoo takes its conservation duties very seriously. In 2009 the attraction launched Natural Vision, a £225-million plan to transform itself into the largest conservation centre in Europe. In 2012 Islands at Chester Zoo was created, designed to recreate six island habitats of south-east Asia. Chester was the first zoo in the UK to successfully breed Asian elephants in captivity. Bull elephant Aung Bo makes his daily appearance in the enclosure; youngster Nandita was born here in August 2015. The virus EEHV has caused the deaths of a number of elephants here. Research into it is continuing and contributions are invited.

The zoo has over 700 animal species, including seventy-nine mammals (1,864 animals) and fifty-two reptiles (230 animals). The islands section includes Sumatran tigers and orangutan.

# 64. The Grosvenor Museum

This very popular public facility, on the far left of Grosvenor Road facing the river, contains a wide range of valuable artefacts, including a collection of Roman carved and engraved

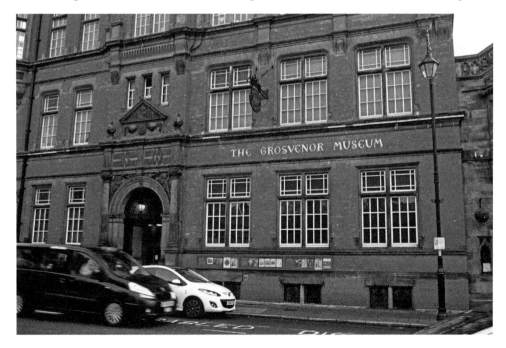

Grosvenor Museum, Grosvenor Road.

stones. It is fascinating to see and touch these artefacts that were created by hand some 2,000 years ago.

The museum was built in 1886 and designed by Thomas M. Lockwood. It contains a wide variety of interesting displays, including rooms decorated and furnished in the style of a particular period.

# 65. Chester Railway Station

Situated in part of the city called Newtown, this spectacular building dates back to 1848. It has seven platforms, and a wall plaque cites Thomas Brassey as the engineer and builder; he was born in Buerton, some 6 miles south of Chester.

Designed by Francis Thompson, the station's front elevation is Italianate. Sculptures are by John Thomas. The building has carved wooden owls set up on the roof to help deter feral pigeons. Robert Stephenson was involved in the station's design in his capacity as an engineer on the Chester & Holyhead Railway. The railway station is built of Staffordshire blue brick and grey sandstone. Pevsner writes, 'One of the most splendid of the early

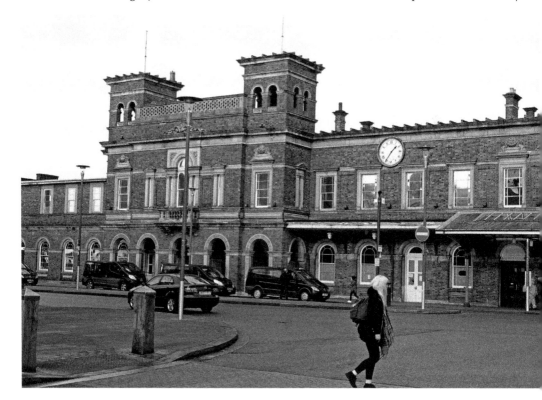

Chester railway station.

railway stations, extremely long and excellently held together. The extensions on both sides display arcading.'

Shrewsbury, Wrexham, Crewe, Llandudno, Holyhead, Manchester Airport and Liverpool Airport are well served from here.

# 66. Lion Salt Works

We all use salt but we spend little time asking ourselves where it comes from. A trip out of Chester to the village of Marston, near Northwich, with the family will have educational value. Next to the site is the Trent & Mersey Canal. This was the UKs last open-pan salt-making site.

Exploring the site will reveal how the salt works operated, and how salt contributed to the economy of mid-Cheshire. A visit to the nearby Weaver Valley, including the Anderton Boat Lift, would also add value.

Salt-making is part of the history of Cheshire – the Romans took advantage of it. Brine pits originally produced salt. In the seventeenth century a number of salt mines were working in the Nantwich region. These bulk deposits were exhausted in the mid-nineteenth century. Subsequently, salt-in-water (brine) was pumped out of the ground and the salt extracted.

In 1894 Henry Thompson built a new business called Lion Salt Works. It closed in 1986.

Domestic use of salt.

# 67. The Deva Roman Experience

Situated in a tucked-away entrance in Peirpoint Lane, off Bridge Street, this is a lively and well-run educational centre, well worth visiting with children from the ages of around seven to eleven. They can physically handle artefacts from 2,000 years ago. A visitor describes it as 'a hidden gem'.

You might catch one of the guides who present public accounts; the staff are articulate and knowledgeable.

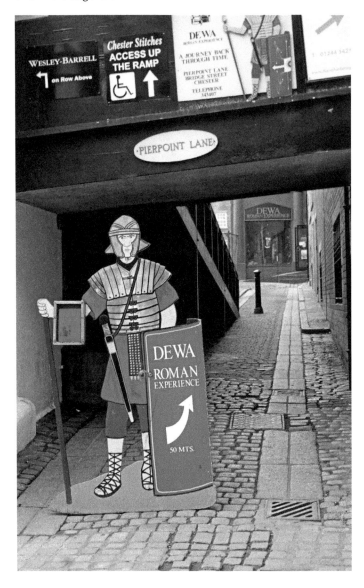

The Deva Roman Experience, Bridge Street.

# 68. Alexander's

Lovers of live jazz and comedy will find their way to this venue because most evenings there are bands and comedy. Situated in Rufus Court, Northgate Street, opposite Chez Jules, an audience of up to 150 can occupy the courtyard. Venues in the garden can take up to 1,000 guests.

Alexander's has a 'close-to-the-performance' ambience as well as a bar that is open through the day. Some of the north's best jazz players and bands play here. A New Orleans pianist, Dale Storr, is featured here twice a year.

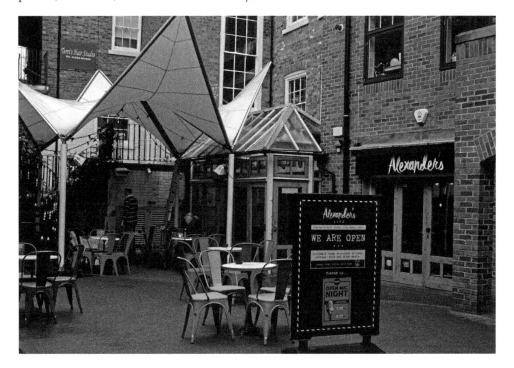

Alexander's, Northgate Street.

# 69. The Brewery Tap

Located in Lower Bridge Street, on the right facing downwards, this distinctive establishment has its own cask beer under the name Spitting Feathers. They also have a range of guest ales. Hand-pulled cider is also served.

Popular at lunchtimes, its menu is displayed outside daily. Offal is a speciality.

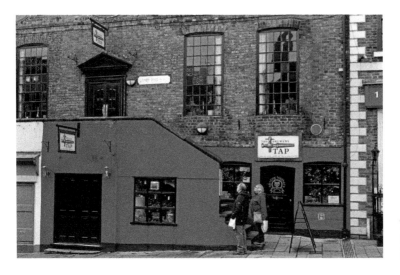

The Brewery Tap, Lower Bridge Street.

# 70. St Michael's Buildings

This Bridge Street façade is huge. It stands out historically because it reveals the power of people to change a disliked, intended new design for one which is liked and traditional.

The original design, by W. T. Lockwood included white faience (glazed blocks of terracotta) with baroque decoration. Faience still remains at street level. The 2nd Duke of Westminster, who had commissioned the new design in 1909, was subject to public pressure. He changed his mind and had the original design removed, replacing it with the present spectacular width of multiple panel black-and-white.

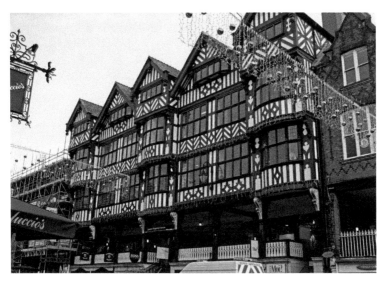

St Michael's Buildings, Bridge Street.

# 71. St Michael's Arcade

This is probably the most beautiful space of the modern era in Chester.

With natural light flooding into this atrium, the work of W. T. Lockwood (1880–1914), a son of Thomas Lockwood, St Michael's Arcade stands out for its symmetry, colour control and reserved elegance.

The Grosvenor Shopping Precinct is a product of the '60s, with its low tunnel walkways, crass shop signs and garish lighting. Walking out of it towards Bridge Street, one steps into a space here that is welcoming and attractive, flanked with restrained shop signs

The wall detailing and the floor tiling are outstanding.

St Michael's Arcade.

# 72. Telford's Warehouse

Thomas Telford (1757–1834), a Scottish shepherd's son, was apprenticed to a stonemason at fourteen. He moved to Edinburgh and then, in 1782, to London. In 1787 he became surveyor of public works for Shropshire and in 1793–1800 planned the Ellesmere Canal. He planned the road from London to Holyhead and designed the Menai Suspension Bridge (1826). He is buried in Westminster Abbey.

Telford's warehouse in Raymond Street, Chester, beside the Shropshire Union Canal, is an interesting architectural survivor. Built in Georgian style around 1790, part of the building is over the canal because it was designed for boats to be loaded and unloaded within the building. In the 1980s, it was converted to a public house. Its main access is to one side of an enclosed square, two sides of which consist of mostly student accommodation.

It is constructed in two blocks of brown brick: the Raymond Street face has two storeys; the block facing Tower Wharf has three. Two arches allow for boats to load and unload. Originally there were loading bays, now converted into windows.

Telford was responding to a local need; the port of Chester was thriving and goods by canal increased.

Now the building houses a public house, a restaurant and is a venue for music groups. In the main bar room there is a magnificent original cast-iron hoist.

Telford's Warehouse restaurant.

# 73. Chester Rowing Club, The Groves

The Chester Rowing Club was founded in 1838 and uses the River Dee. It has an extensive range of boats and the members are glad to see anybody who wishes to take up rowing.

The club has a well-equipped HQ and there is an active social life.

Chester Rowing Club, River Dee.

# 74. Sandy Lane Park

This area of land consists of an empty plot of meadowland, adjacent to the river, and a square of children's play items, some 2 miles to the east of the centre of Chester, on the north bank of the Dee, where it makes a long loop. It is in the Boughton suburb, accessed off the A51, Cristleton Road.

It has wide views of the Meadow, the grassy area that runs along the south side of the River Dee. It is an ideal place to sit and admire the river; however, it could do with some picnic tables.

Sandy Lane Park.

# 75. Chester Mystery Plays

## DID YOU KNOW ?

The Chester Mystery Plays are an important part of the history of theatre in Britain. The roots of the Tudor theatre renaissance are, to a significant extent, based in this old convention.

The Mystery Plays of Chester were first recorded in 1422 when they were put on in public during the feast of Corpus Christie. The plays *The Trial and Flagellation of Christ* and *The Crucifixion* were played in Chester on Corpus Christie Day, 1475. Later, they were played during a three-day cycle on Whit Monday, Tuesday and Wednesday.

The plays were based on biblical stories with a strong religious theme. Guildsmen and craftsmen took the parts; the performances took place in the open air, with stages erected in various streets. Before the performance, the town crier would announce the event.

An established group has taken responsibility for staging the Chester Mystery Plays every five years. They were performed inside the cathedral in 2013, the first time they had been performed inside a church in hundreds of years. Chester Mystery Plays Ltd was created in the 1980s, with the intention of keeping the tradition of these plays alive.

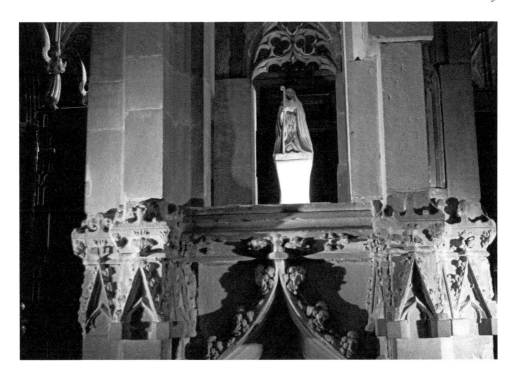

A old part of the interior of the cathedral.

# 76. Walmoor Hill

Situated to the east of central Chester, above Sandy Lane on Dee Banks, this enormous house was designed in 1896 by architect John Douglas for himself and his family. He lived here until his death in 1911; then his son Sholto lived here until 1918. Subsequently, it became a girls' school, then a boys' school, and then the headquarters for the Chester Fire Brigade, which ended in 1997.

The building is flanked by acres of very valuable land, most of which is laid down to grass and woodland. The house is now divided into three residential sections. Its front elevation, facing the river and Grosvenor Estate land, incorporates an effigy of Queen Victoria and the bear-and-staff emblem of Warwickshire. The front door is headed by the emblem of the Douglas family. The windows are highly decorated, some including coloured images.

Pevsner says, 'It is a stone house of considerable panache, proof of the wealth a successful provincial architect could assemble.'

This is a Grade II-listed building, known locally as 'Douglas Castle'.

Built of red sandstone with a Welsh slate roof, a private chapel is incorporated above the portal. It has mullioned and transomed windows. To the west is a tower with a crenelated

Walmoor Hill, home of John Douglas.

parapet and a pyramidical roof. The ground falls steeply towards the river, and from below the building appears to have four storeys. The monograms 'JD' and 'STD' (Sholto Theodore Douglas) appear on the building. The staircase is edged with a stained-glass window commemorating Captain Richard Douglas, who died in the Peninsular War.

It is a remarkable building, which deserves to be carefully maintained.

In the same road, Nos. 31–33 are also, earlier, by John Douglas.

# 77. City Walls

**DID YOU KNOW ?**

Chester's city walls are nearly 2 miles in circumference.

Chester's city walls offer intermittent sections of walkway, with excellent views of the city's centre. They enclose the original, medieval walled town. The east and north walls have Roman foundations. Much of the restoration work was carried out in the thirteenth

Chester city walls.

century, with further additions during the time of the Civil War. The walls' height is between 15 and 25 feet; the width between 5 and 6 feet.

The Phoenix Tower, accessed from Eastgate Street, northwards, is semi-circular and marks the north-east angle of the Roman and medieval defences. It was rebuilt and refaced in the eighteenth century. The tower is around 70 feet high. The lower chamber is the oldest. Above the round-arched doorway is a plaque, of 1613, commemorating the use of the space by one of the city guilds (painters, glaziers, embroiderers and stationers). The lower room has five arrow slits for effective wide-range defence. Beyond Northgate lie five towers: the rectangular Morgan's Mount, Goblins' Tower, Pembreton's Parlour and the rectangular Bonewaldesthorn's Tower, which stands at the north-west angle of the medieval walls, close to the Water Tower (1322–26), built to defend the former harbour. Other towers feature on the extension of the walls.

# 78. Minerva's Shrine

Minerva's Shrine is located in Handbridge on the west side of Edgar's Field. It is in the open air and has been subject to much weather deterioration. However, it is historically important, dating from the early second century. It is one of the few structures in the area where one can actually go up to and touch an object that is some 1,800 years old.

Minerva's shrine.

Minerva was a Roman goddess. She is often depicted wearing a helmet, breastplate and carrying a sword. The shrine is located close to where the Romans entered the city of Chester.

A moulded copy of this shrine is in the Grosvenor Museum.

# 79. Chester Philharmonic Orchestra

Founded in 1884, this is one of the main non-professional orchestras in the north of England. It enjoys a wide group of players capable of playing most pieces in the symphonic repertoire.

Rehearsals are on Monday evenings at the All Saints Church, Hoole. String players are urged to contact the orchestra.

Four or five concerts are put on each year, usually in the cathedral.

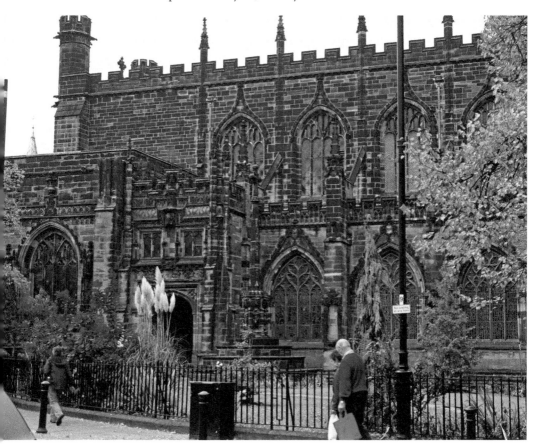

Chester Cathedral.

# 80. The Boat House

Facing the Dee, now a pub and hotel, The Boat House's secret is that it has a floating section. At night, diners and drinkers enjoy sitting out on a platform that rests on the River Dee.

The Boat House restaurant.

# 81. 'The Bore' – Seen No More

**DID YOU KNOW ?**

There was a bore on the River Dee.

Thomas de Quincey (1785–1859) was educated at Manchester Grammar School. He is known in English literature as the author of *Confessions of an English Opium Eater*. During his early years, his mother lived in Chester. In July 1801 Thomas left his school and set off on a walk to the Lake District and made the acquaintance of William Wordsworth, whose

River Dee – bore.

work he admired. He also wanted to see his sister Mary, who was living with his mother in Chester. He wrote,

> The distance between Manchester and Chester was about 40 miles. This I planned to walk in two days. I wished to bisect the journey ... in a clean roadside inn, of a class so commonly found in England ... a safe and profound night's rest. On the following morning there remained not quite eighteen miles between myself and venerable Chester. I saw held aloft before my eyes that matchless spectacle an elaborate and pompous sunset hanging over the mountains of North Wales.
>
> I descended into some obscure lane that brought me to the banks of the River Dee. I was walking along this bank, with no-one else in sight except a woman of middle-age, dressed in rustic fashion, when suddenly ... an uproar of tumultuous sound rising clamorously ahead. From round the bend of the river came an angry clamour. What was it? Earthquake? Convulsion of the earth? There came as with the trampling of cavalry a huge charging block of water, filling the whole channel and coming down on us at the rate of forty miles an hour [he approached a woman] despite the fact that I had never spoken to her. 'It was the Bore' she said, 'an affliction to which only some few rivers here and there are liable'.

The tidal bore happened on the Dee each day before silting altered the flow of the river. This silting seriously diminished the business of shipping through the port of Chester.

# 82. Game Plan at the Market

Chester Market Hall sells nearly everything. One visit will equip you with all that you need – from watch batteries to quail.

There used to be nine butchers, but now there are three – at the front by the door with two on the right and one on the left.

The three business owners have been there for over twenty-five years. The secret of their business is knowing the requirements of their customers and giving high-quality service. The secret is 'personal'.

The popular game mix prepared by Mark Johns and his wife Julie (trading as Fernyhough) is one of their specialities. They offer a variety of game: rabbit, pheasant, wood pigeon, wild boar, venison, partridge and mallard. The last-named is regularly stocked and is more popular than goose. Turkeys, hand-reared at a Cilcain Farm, are here for Christmas. Turkeys and geese, locally reared, are also available at the other two butchers.

Chester indoor market.

# 83. One of the Oldest Churches in Europe

On the site of St John the Baptist Church there was, some scholars argue, a church dating from the third or fourth century. However, records show that from 1075 to the Reformation this church was the cathedral and collegiate church of the city of Chester. After the Reformation, the previous Abbey of St Werburgh, because it was in better condition, became the formal cathedral.

King Edgar of England came here, holding his court at Edgar's Field, Handbridge – he was rowed to this church. Edward I took the Welsh nobility in, swearing an oath for his support here. In Wales, thirteenth-century poets wrote in praise of St John's and the thirteenth century saw major building. The Welsh chief Owain Glyndwr swore his allegiance to the Court of Chivalry here in 1386. Parish registers began in 1559 and, in 1581, Elizabeth I granted monies for rebuilding.

Most of the interior is Norman. There are many effigies inside from as far back as the thirteenth and fourteenth centuries. In 1888, John Douglas rebuilt the porch and, in 1886, redesigned the north-east tower. The reredos (an ornamental screen behind an altar) is by John Douglas and was made by Morris & Co. (the firm run by the famous designer William Morris).

The north aisle contains a memorial to Thomas M. Lockwood.

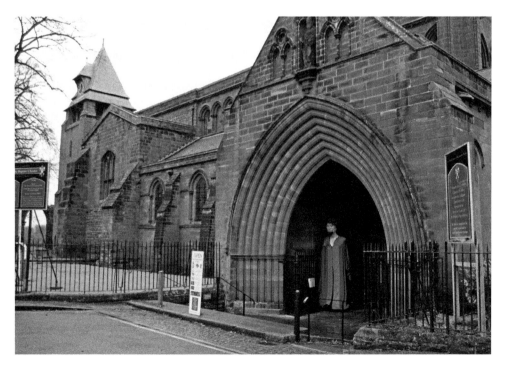

St John's Baptist Church.

# 84. King Arthur and Chester

Here we are entering a territory that fully deserves the description 'hidden'. Leaving aside the stories and legends (Tennyson *et al*), we ask ourselves was there an original Arthur, a real Arthur of history? If there was not, why did a number of writers (in Welsh and English) from the seventh century to the thirteenth century confidently refer to Arthur the military leader? Granted he was not a king; he was a leader of men in battle, a warrior chief. 'General' might be a better term for him. He was a Celt. His name derives from 'arth', the Welsh for bear. He brought his fighting Welsh to battle. He rose up against the Germanic Angles, Saxons and Jutes (Anglo-Saxons) who conquered much of Britain between the fifth and seventh centuries. We propose that his home territory was the 'marchland' of the Welsh border – the present counties of Cheshire, Shropshire, Staffordshire, Gloucestershire, Herefordshire and Monmouthshire. He would have wanted his control spread over land that was fertile and better cultivated and lived in than the highlands of Wales, which included the bleak Berwyn and the Cambrian mountain ranges.

Many historians refer to the text of Geoffrey of Monmouth, purporting to be an account of the history of Britain. Material here is drawn from an earlier text of the eighth century,

Three stages of Chester construction. A Victorian bridge on the left with Norman wall overshadowing south-east Roman tower ruins.

where Arthur is referred to as *Dux Bellorum* (leader of battles). In an alleged list of battles, the ninth is said to have taken place in *urbe legiones* (in the city of legions), which is most likely Chester.

He lived around AD 500, some 130 years after the Romans left Britain. It would be natural for Arthur to take advantage of what the Romans left behind. He and his men may well have lived in camps and residences built by the Romans, with their sound construction, protection and warmth, drainage, baths and surrounding walls or palisades for defence. Chester would have been an ideal headquarters for him: it had developed domestic structures, a defensive system, and was close to Wales where he and his men could withdraw to in the event of a serious attack.

For much of what we call the 'Dark Ages' Chester was part of Wales. The region of Powys covered the eastern part of north and central Wales, including Chester and parts of what is now Cheshire.

# 85. The Suspension Bridge

This is a good place from which to admire the view: facing upstream, Queen's Park on your right, the old city on your left.

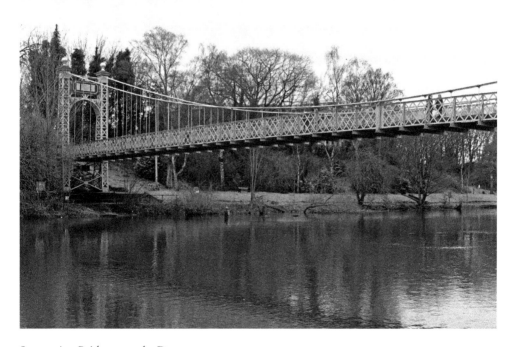

Suspension Bridge over the Dee.

This is not the original bridge. The first suspension footbridge was built here in 1852. In the early 1920s the Corporation of Chester decided to abolish it. A new bridge was designed and built – and has been restored twice.

It is one of four bridges that cross the Dee in Chester. People have been attaching padlocks to this bridge, but the word was put out that this should cease because it adds weight to the structure, making it less safe in high winds.

# 86. Chester History and Heritage Centre

Situated in St Michael's Church, Bridge Street Row, this is part of West Chester Museums.

It is an excellent centre for knowledge of the city. A newsletter containing interesting articles is published and exhibitions and film shows are put on. The staff are always happy to answer queries.

Chester History and Heritage Centre.

# 87. The Grosvenor Dynasty

The Grosvenor family have been the backbone of Chester for many centuries. They have rejuvenated the city, financing new developments, allocating land, and so on.

The family settled in England before the fifteenth century, and they possessed the Manor of Eaton. The public-spirited origin of the family lies with Sir Richard Grosvenor (1584–1645), 1st Baronet and MP. The Earls of Grosvenor started with Richard Grosvenor (1784–1802). The Dukes of Westminster started in 1874 and Queen Victoria bestowed this on Hugh Grosvenor.

The Grosvenor Estate in London dates back to 1677, when Mary Davies married Sir Thomas Grosvenor, 3rd Baronet. As was the custom, her properties became the property of her husband; this included the manor of Ebury, 500 acres of land north of the Thames to the west of the city. Later, the Grosvenors developed Mayfair around Grosvenor Square. In the 1820s they developed Belgravia, Chester Square, Eaton Square, and surroundings.

In the 1950s, the business was expanded to Canada and the Americas, with Australia and the Asia Pacific following in the 1960s. The 1990s saw expansion into Continental Europe. The fund management section was created in 2005.

The current holder of the title Duke of Westminster is Hugh Grosvenor (born 29 January 1991), who inherited the title on 9 August 2016 following the death of his father, Gerald. The duke lives at Grosvenor House, Park Lane, London, and at the family seat in Chester, Eaton Hall.

According to the *Sunday Times* Rich List 2016, the total wealth of Gerald Grosvenor was £9.35 billion. He was the third richest British citizen.

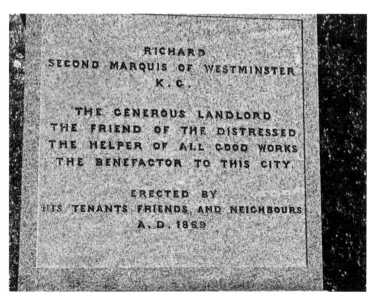

The Grosvenor dynasty.

# About the Author

John Idris Jones was born in Llanrhaeadr-ym-Mochant, mid Wales. His secondary schooling was at Brynhyfryd School, Ruthin, and he attended the universities of Keele, Leeds and Cornell. His prose verse is included in many anthologies. He published *Accord*, a collection of poetry, in 2010 (Cinnamon Press); a short novel, *Madocks*, in 2012 (Alun Books); and *Slate, Sail and Steam: a History of the Industries of Porthmadog* (Amberley Publishing) in 2016. He lives in Ruthin, Denbighshire.

JIJ, May 2017